IMAGES
of America

SAN FRANCISCO
LANDMARKS

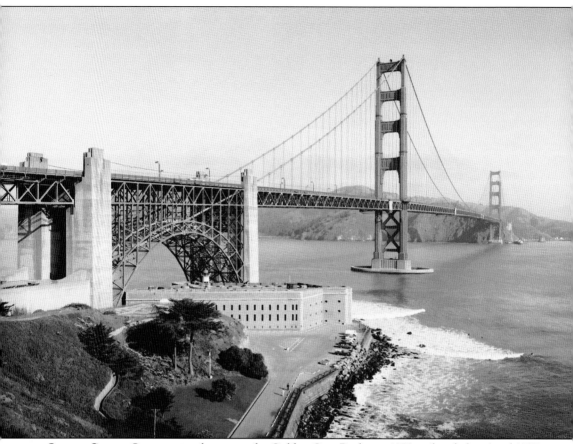

ON THE COVER: Construction began on the Golden Gate Bridge in 1933 and ended in April 1937. The bridge was dedicated on May 27, 1937. Engineer Joseph Strauss and architect Irving Morrow created a spectacular and beloved international landmark in a magnificent setting. The 4,200-foot span between two streamlined, modern towers was the longest bridge in the world until 1959. Fort Point, nested adjacent to the bridge, was built between 1853 and 1861; in 1864, the fort covered 290 acres. Overlooking the Golden Gate, the fort protected San Francisco Harbor from attack during and after the US Civil War. Golden Gate Bridge: San Francisco Landmark No. 222, California Landmark No. 974; Fort Point: National Register No. 70000146. (Library of Congress.)

IMAGES
of America

SAN FRANCISCO LANDMARKS

Catherine Accardi

ARCADIA
PUBLISHING

Copyright © 2012 by Catherine Accardi
ISBN 978-0-7385-9580-1

Published by Arcadia Publishing
Charleston, South Carolina

Printed in the United States of America

Library of Congress Control Number: 2012935709

For all general information, please contact Arcadia Publishing:
Telephone 843-853-2070
Fax 843-853-0044
E-mail sales@arcadiapublishing.com
For customer service and orders:
Toll-Free 1-888-313-2665

Visit us on the Internet at www.arcadiapublishing.com

*This book is dedicated to the Golden Gate Bridge
on its 75th anniversary, May 27, 2012.*

CONTENTS

ACKNOWLEDGMENTS

The images in this volume are courtesy of the Library of Congress, Prints and Photographs Division (LOC); Catherine A. Accardi (CAA), photographer; and Richard Monaco, J.B. Monaco Collection, San Francisco Public Library (JBM). Images were also purchased from the San Francisco History Center at the San Francisco Public Library (SFHC).

INTRODUCTION

In this volume, *San Francisco Landmarks*, vintage photographs and captions describe San Francisco's evolution into one of America's most historic and captivating cities. Landmarks are the best elements of a city's urban fabric, and each one embodies the characteristics of the surrounding community. It is not just visitors who marvel and enjoy the experiences of San Francisco; residents adore their city, many saying they would not live anywhere else. I like to think of the whole of San Francisco as a landmark.

San Francisco is one of the most interesting and unique cities in the world, expressed by its stunning topography, neighborhood culture, the arts, and a unique array of architectural styles, just to name a few. The "City by the Bay" occupies 47.355 square miles with a city limit that extends 32 miles out to sea because the boundaries of the city and county of San Francisco include the federal property of the seven Farallon Islands. Of the 43 named hills in San Francisco, Mount Davidson is the highest at 938 feet. Every characteristic that makes San Francisco distinct is represented in the city's landmarks, including Coit Tower, Bayview Opera House, Palace of Fine Arts, Golden Gate Bridge, and many charming Victorian-style structures.

Four chapters chronicle the story of the city's landmarks, beginning with the first, Mission Dolores, built in 1776, to the last, the Crown Zellerbach Building, built in 1959. At the time of this printing, San Francisco boasts 493 designated landmarks, created over a period of 183 years. Using vintage photographs and drawings, each with accompanying captions, this book will highlight the pertinent facts about each landmark.

At home, at work, and at play, landmarks are a part of everyday life in San Francisco, and they are woven into the fabric of daily life. Residents want to know why there is a monument in their neighborhood park and why the delightful Victorians next door have a historic plaque by the front steps. And tourists can enjoy their stays in San Francisco visiting major attractions, many of which are designated landmarks. Landmark designations are based on their significance in several categories, including economic, cultural, historic, and environmental. Criteria for historic landmark designation, whether local, state, or national, requires the quality of significance in one, or more, of four categories: events that are associated with significant contributions to the broad patterns of our history; people that are associated with the lives of persons significant in our past; design/construction that embodies the distinctive characteristics of a type, period, and/or method of construction that represent the work of a master and that possess high artistic values; or informational value that has yielded facts important in prehistory or history.

Local designations (within city boundaries) are approved by the San Francisco Landmarks Preservation Advisory Board, established in 1967. Article 10 of the Planning Code sets forth the guidelines for local landmark designations. As of this printing, there are 260 local landmarks and 11 historic districts in the city and county of San Francisco. The first structure to be designated a local landmark in San Francisco was Mission Dolores, dating from 1776, officially designated on April 11, 1968, and featured on pages 117 and 118.

A California landmark can be a building, structure, site, or place that is considered to have statewide historical significance. There are currently 49 designated state landmarks in San Francisco, the first being the Presidio, dating from 1776, officially designated in 1965, and

featured on page 93. On September 17, 1776, the Presidio of San Francisco was formally acquired as a Spanish fort. The Spanish built the Presidio on the hill where the Golden Gate Bridge now meets San Francisco.

National landmarks are those places that have significant historical importance illustrating or interpreting the heritage of the United States. Less than 2,500 sites currently have this designation. San Francisco boasts 19 designated national landmarks; the first was the Old Mint, constructed in 1869, designated on July 4, 1961, and featured on page 103.

The article "An 'Unvanished' Story, 5,500 Years of History in the Vicinity of Seventh & Mission Streets, San Francisco" states: "During prehistoric and early historic times, a large marsh protruded inland south of Rincon Hill as far west as Seventh and Mission Streets. Prehistoric mounds, containing artifacts dating back to at least 2,000 years ago, were found on Hunters Point, some near the shore at Candlestick Park. The people of these mounds may have been the ancestors of the Costanoans, as the Spanish named the coast people."

Aboriginal inhabitants of San Francisco, the Muwekma Ohlone tribe, consider the San Francisco area as their original homeland. During the late 1700s, when Spanish settlers colonized Alta California, the area was home to more than 300,000 Native Americans, a larger number than any equivalent area north of Mexico. Although no officially designated landmarks can be attributed to these first Native Americans, the first designated local landmark, Mission Dolores, was constructed in part with Native American laborers.

This book will chronicle designations from the 1700s through the 1850s, represented by Ghirardelli Square and the US mint, among others. The early days, from the 1860s to the 1870s, will be represented by Lotta's Fountain, Hotaling Buildings, and the House of the Flag. Landmarks dating from the end of the century, 1880s through the 1890s, include the Audiffred Building, cable car barn, and powerhouse. A new decade, the 1900s to 1910s, brought the Bank of California, Palace Hotel, Ferry Building, and the Palace of Fine Arts. A growing sophisticated city began from the 1920s to the 1950s, with the Orpheum Theater, Golden Gate Bridge, and the Beach Chalet.

Chapter one, "Residences: Where People Lived," will tell the collective story of San Francisco's residences, from the city's beginning to the 20th century, highlighting structures such as cottages, hotels, and mansions. Examples include the Victorians on Alamo Square, the earthquake shacks, and the Palace Hotel. A historic residence can be a stately home, the birthplace of a famous person, or a dwelling with an interesting history or architecture. As with all designated landmarks, residences must meet criteria based on significant historic events, persons, design/construction, or documentation of history.

When the California Gold Rush attracted hundreds of people to the state, miners lived in tents fabricated with cloth, paper, and wood. Later, simple cottages and Carpenter Gothic–style dwellings gained popularity. By the 1850s, residences that were more elaborate in the style of the Abner Phelps House, featured on page 13, grew in popularity among successful San Francisco businesspersons. There are several accounts of the Phelps house's origin. The earliest published account (August 8, 1934) states that the house was "built in 1850 by John Middleton and Sons, one of the first real estate concerns in the city . . . constructed of lumber into sections brought round the Horn from Maine, there being no sawmills here at the time." However, in 1961, a Phelps family descendant stated the house had been purchased in New Orleans in 1850 and shipped in sections around the Horn. In either case, the Abner Phelps House is considered the oldest unaltered residence in San Francisco, making it a significant example of a residential landmark.

Some of the landmark dwellings are distinguished by multiple designations. For example, the McElroy Octagon House is both a local and national landmark. Ambassadors from the past, the historic dwellings capture and preserve San Francisco's colorful and fascinating history. Other examples will include the architectural gem Flood Mansion. It represents significant architectural design, a famous person, and a 1906 survivor.

The small but adequately designed earthquake refugee shack represents the story of thousands of families who lost their homes after the great earthquake and fire of 1906. Some 5,610 wooden cottages were built and leased, most of them 10 feet by 14 feet. By the summer of 1908, the cottages

had been purchased by individuals and moved to private lots. Only a handful of the cottages survive, and most have been expanded and altered similarly to the one on Twenty-fourth Avenue.

Residential districts such as Blackstone Court, bounded by Lombard, Greenwich, Franklin, and Gough Streets, reflect working-class life in the early 1800s. Blackstone Court is an example of a designated historic residential district. The northern section is adjacent to an early trail shown on coastal survey maps of the 1850s, and the trail ran towards the Presidio.

The Dogpatch Historic District bounded by Mariposa, Tubbs, Third, and Indiana Streets is another example of a historic working-class area of San Francisco. Dogpatch typifies the mixed industrial/residential districts of San Francisco prior to the 1906 earthquake and fire. Because the marshland surrounding the area saved the Dogpatch from complete devastation, historically significant buildings constructed between the 1860s and 1910 can be found in the area, with many examples of working-class family houses built by the residents themselves.

Chapter two, "Businesses: Where People Worked," will highlight San Francisco's prominence in the early banking, shipping, and fishing enterprises, just to name a few. San Francisco's location is ideal, just about in the center of the state, at the mouth of the golden gate, situated around a bay, and with access to maritime industries and all points north, south, east, and west. As the nucleus of early Bay Area economy, San Francisco was the hub of mining after the discovery of gold in 1849. Rare photographs dating from the 1850s show hundreds of ships anchored in the bay. Thousands of new residents demanded goods and services; food, clothing, newspapers, shops, and hotels flourished. Chapter two will focus on unique places of employment like the Albion Brewery, original Transamerica building, and the Bank of Italy (later the Bank of America).

Like the landmarks in chapter one, the Dogpatch Historic District was significant in San Francisco's early industrial economy, then centered in the city's central waterfront area. After the 1848 Gold Rush, the city evolved from a relatively quiet hamlet into a world seaport. By the late 1860s, Dogpatch was the center of heavy industry, employing hundreds of workers. Potrero Point was located on San Francisco's eastern waterfront near today's Pier 70. For 100 years, this site was considered the most important location for heavy industries in the western United States.

Other examples of San Francisco's business related landmarks, documented in chapter two, will include the C.A. *Thayer* lumber schooner. Constructed in California in 1895, the *Thayer* is a wooden-hulled, three-masted schooner designed for transporting lumber. An example of a completely different enterprise is the nationally designated Bank of Italy, founded in 1904 by Amadeo Giannini. It grew to become the Bank of America. Originally, the Bank of Italy was founded to assist working-class residents of North Beach; after the 1906 earthquake and fire, the bank was one of the few to offer loans to rebuild San Francisco.

Chapter three, "Recreation: Where People Frolicked," will delight the reader with images of neighborhood parks such as Washington Square, a social gathering place bounded by Columbus Avenue and Stockton, Filbert, and Union Streets. Designed around 1850 by William Eddy, it was one of San Francisco's three original parks and is featured on page 75. Chapter three will present exceptional places for entertainment, the arts, and epicurean delights, such as the Bayview Opera House, Golden Gate Park Conservatory, Palace of Fine Arts, and Jack's Restaurant.

Woodward's Gardens, at Mission and Duboce Streets, no longer exists, but the site is designated a California landmark. Its heyday was between 1856 and 1892. R.B. Woodward opened his gardens to the public as an amusement park that ranked as San Francisco's most popular resort.

Citizens enjoyed the Bayview Opera House (also referred to as the South San Francisco Opera House) at 1601 Newcomb Avenue when it was built back in 1888. Historians declare the structure was a performance venue in its heyday, and it is the only remaining pre-fire theater in San Francisco, now city landmark no. 8. The opera house was built by Masonic Lodge No. 212 and designed by German-born architect Henry Geilfuss. It was the first cultural building constructed in the Bayview Hunters Point neighborhood, then known as South San Francisco, a fledgling district of cottages, farms, and slaughterhouses at the city's southeast corner.

The fun and games continued at the Liberty Bell Slot Machine site at 406 Market Street. Back in 1898, Charles August Fey invented and manufactured the first slot machine right there at his

Market Street workshop. Fey was a pioneer in coin-operated gaming devices and was responsible for many of the innovations we enjoy today.

Golden Gate Park, dating from 1900, is known worldwide for its pastoral expanses of elegantly manicured lawns and plants. Along with the Palace of Fine Arts in the marina, these outdoor landmarks reveal the charms of the City by the Bay.

In Chapter four, "Civic: Government and Community Places," vintage photographs showcase civic architecture, from missions to skyscrapers. These impressive structures express the way the community wants others to see it and inspire its citizens, present and future, by reflecting America's civic and architectural history. Chapter four will describe distinctive public and government buildings and monuments like city hall, Federal Reserve Bank, Mission Dolores, Lotta's Fountain, and Coit Tower.

San Francisco's architectural and public space masterpiece, the civic center complex, is comprised of 456 acres and 19 buildings. The design of the San Francisco Civic Center had its origins in the City Beautiful movement. This aesthetic is expressed in monumental classical architecture for the city's central public spaces, and it expresses the belief that such enjoyable surroundings should be available to all citizens. The civic center consists of city hall, the opera house, state building, civic auditorium, the department of public health, federal building, public library, and public plaza. Also in this chapter are churches, schools, monuments, post offices, fire stations, and bridges.

Churches include Old St. Mary's and Trinity Episcopal. Coit Tower, surrounded by Pioneer Park, is itself an internationally beloved monument to San Francisco's firefighters. The first public school site in Portsmouth Plaza is described in chapter four, as are several libraries, the Carnegie libraries in particular. Irving Scott School, built in 1895 to serve the children from Dogpatch, is San Francisco's oldest existing public school building. The building was named after the head of the nearby Union Iron Works shipyard and still stands at 1060 Tennessee Street. A few blocks away is one of San Francisco's oldest firehouses, Firehouse No. 16. Constructed in the 1890s, it housed fire wagons powered by teams of horses. All of the public structures are important sites for city development, management, and community service. These buildings provide the connection between citizens, cities, the state, national offices, and beyond.

San Francisco's Landmarks will assist in the interpretation of the heritage of a unique city. All of San Francisco's 493 landmarks are perfect images of America.

One

RESIDENCES
WHERE PEOPLE LIVED

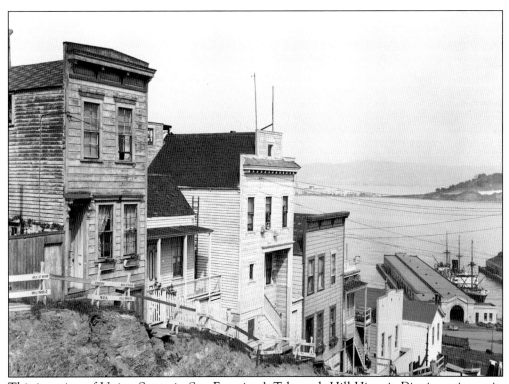

This is a view of Union Street in San Francisco's Telegraph Hill Historic District as it was in 1940. In the distance is Treasure Island, with the ongoing Golden Gate International Exposition. The area dates back to the discovery of San Francisco Bay in the 1770s. These charming old residences are from the 1800s, and the district boasts the largest number of pre-1870 structures, several even dating back to the 1850s. (LOC.)

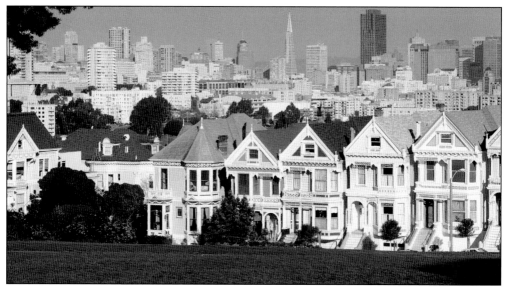

San Francisco's Alamo Square Historic District, bounded by Golden Gate Avenue and Divisadero, Webster, and Fell Streets, includes 276 properties, significant for residential design from the 1870s to the 1920s. Individual landmarks within the district include the Archbishop's Mansion and Westerfeld House. San Francisco Planning Code, Article 10 describes the district as having a variety of renowned architectural styles, unified by its residential character and relatively small scale, and highlighted with intense ornamentation. This image, taken from Alamo Square Park, shows charming Victorians on Steiner Street, often referred to as "Postcard Row." (SFHC.)

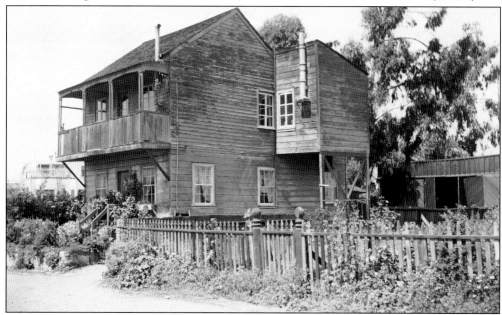

The Blackstone Court Historic District, bounded by Lombard, Franklin, Gough, and Greenwich Streets, is an enclave of five structures, including the Blackstone House, thought to have been constructed on an early trail that led to the Presidio. The area contains residences dating to the early 1850s. This area of San Francisco consisted mostly of small farms and open fields, along with Washerwomen's Lagoon, all nestled in what was then called Golden Gate Valley. (LOC.)

Historic records suggest the Abner Phelps House at 1111 Oak Street, built in 1850, is the oldest surviving residence in San Francisco. Constructed by John Middleton and Sons, one of the first real estate companies in the city, it was originally thought to be built from Maine lumber. Research that is more recent indicates the house was built from California redwood. San Francisco Landmark No. 32, National Register No. 71000187. (LOC.)

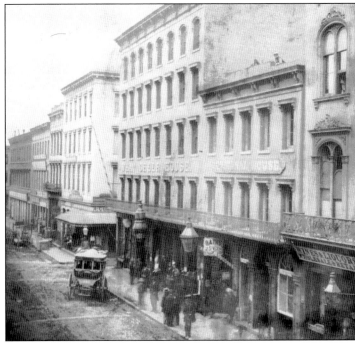

The What Cheer House, at Sacramento and Leidesdroff Streets, was one of the largest hotels in the city in the 1850s. The landmark plaque on the side of a nearby building on Leidesdorff reads: "This is the site of the famous What Cheer House, a unique hotel opened in 1852 by R.B. Woodward and destroyed by the fire of 1906. The What Cheer House catered to men only, permitted no liquor on the premises, and housed San Francisco's first free library and first museum." California Landmark No. 650. (LOC.)

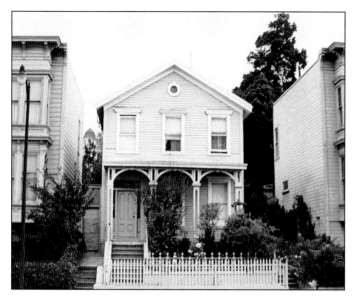

When this residence was built at 2006 Bush Street in 1854, it was only five years after the California Gold Rush and Bush Street was still a young thoroughfare. The first resident was San Francisco supervisor Charles Stanyan, after whom the house has been named. Stanyan was a prominent citizen who helped obtain the land for Golden Gate Park. This residence remained in the Stanyan family for over 100 years. San Francisco Landmark No. 66. (SFHC.)

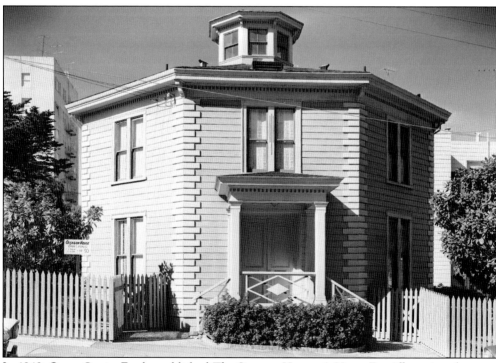

In 1848, Orson Squire Fowler published *The Octagon House: A Home For All,* stating the most efficient shapes for a house are the circle and octagon. Several thousand octagon houses were built in the United States and Canada, and two survive in San Francisco. The one pictured is the McElroy Octagon House at 2645 Gough Street. San Francisco Landmark No. 17, National Register No. 72000250. (LOC.)

One of the first Europeans to make note of Telegraph Hill was Capt. Juan Manuel de Ayala on August 5, 1775. Early residents were working-class immigrants, and accounts describe the eastern slope of Telegraph Hill as "swarmed with goats." At that time, the hill was dotted with tents, rustic buildings, and dirt paths. Below is a photograph of a house on Telegraph Hill, complete with a dog and chicken. In the center, shown above, is the John Cooney house, built in the mid-1800s, at 291 Union Street. Fishing and shipping industries were important to the hill, as were the station house and telegraph pole, erected in the 1850s. It signaled the arrival of approaching ships in San Francisco Bay, thus the name Telegraph Hill. San Francisco Historic District, California Landmark No. 91. (Above, LOC; below, JBM.)

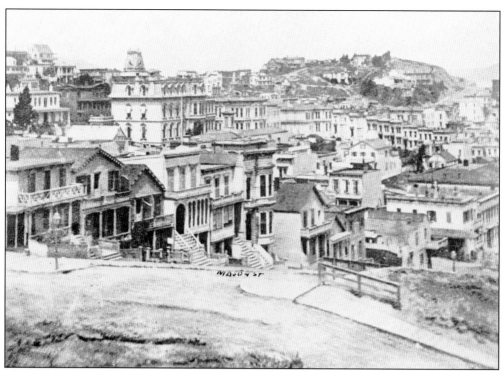

The Russian Hill-Vallejo Street Crest Historic District is bounded by Broadway, Vallejo, Jones, and Taylor Streets. The neighborhood's name goes back to the Gold Rush era, when settlers discovered a small Russian cemetery under what are now the Vallejo Street stairs. Homes and stairways throughout Russian Hill were the creations of some of California's most notable architects, including Willis Polk, Julia Morgan, and Bernard Maybeck. The area was home to Bret Harte, George Sterling, and Ina Coolbrith. When the 40-acre district was added to the National Register on January 22, 1988, it contained 26 contributing buildings, two contributing sites, and five contributing structures. Above is the view from the corner of Mason and Sacramento Streets, and the c. 1865 image below shows Green Street. National Register No. 87002289. (Both, LOC.)

Rincon Hill, one of the first posh neighborhoods in San Francisco, has its origins in the 1840s. The hill rose about 120 feet above the surrounding sand dunes and eventually gained popularity with the elite in the 1860s. It included the homes of William Tecumseh Sherman, William Ralston, William Gwin, and H.H. Bancroft. The image above shows Rincon Hill in the distance, and below is the residence of Lawrence Coe at Harrison and Essex Streets around 1866. By the 1880s, the hill, already partially leveled, became a working-class district. A historic plaque at Rincon and Bryant Streets now commemorates the area. California Landmark No. 84. (Both, LOC.)

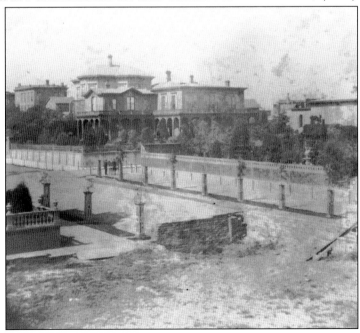

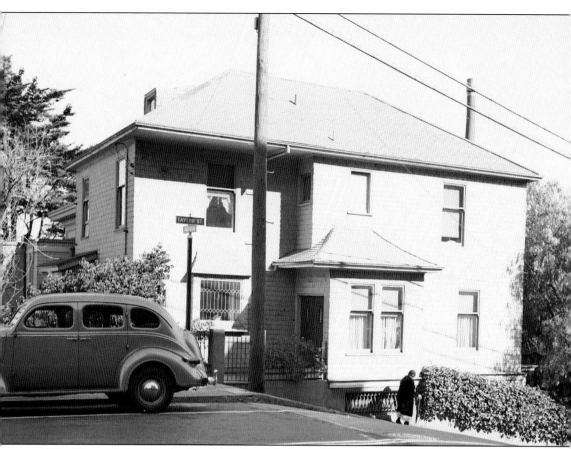

The House of the Flag, built in 1860 (modified in 1903), is also known as the Sheppard-Dakin House. It was once owned by retired American diplomat and attorney Eli Sheppard and later by flag collector and publisher Edward A. Dankin. Located at 1652–1656 Taylor Street, it is best known for being dramatically rescued from the 1906 earthquake fire. As the fire approached, Dakin raised the American flag on a staff beside the house. Impressed by the valiancy of this gesture, a company of soldiers was inspired to charge up the hill to fight the fire. It is reported that the soldiers found a bathtub full of water and sand to douse the flames. Since then, it has been referred to as the House of the Flag. San Francisco Landmark No. 46. (LOC.)

In 1865, Pierce Street was a country road that connected Cow Hollow to Washerwoman's Lagoon. It was in this area that Henry Casebolt decided to build a residence on a hill at 2727 Pierce Street, very near to his carriage factory in Cow Hollow. Casebolt was a Virginia blacksmith who brought his family to San Francisco in 1851. His home is considered to be a noteworthy example of Italianate style. San Francisco Landmark No. 51. (SFHC.)

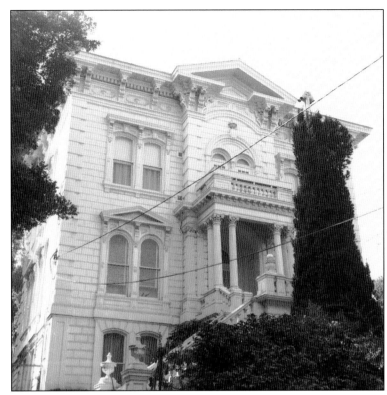

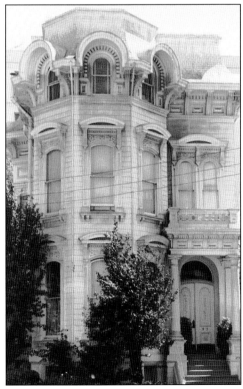

Philanthropist and pioneer Adolph Sutro built this beautiful Victorian mansion in 1870 for his daughter Emma and her husband, Dr. George Merritt. It is located at 2355 Washington Street in Pacific Heights and is now called the Dallam-Merritt House, built in the Italianate style. National Register No. 84001185. (SFHC.)

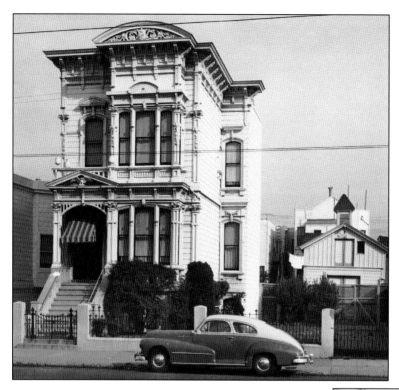

Charles Havens was San Francisco's city architect. He designed the Havens Mansion, at 1381 South Van Ness Avenue, as his personal residence in 1884. It is considered an excellent example of the Second Empire architectural style. The firm of Havens and Tope also designed the San Francisco Yacht Club and the Flatiron Building at 540 Market Street. San Francisco Landmark No. 125. (SFHC.)

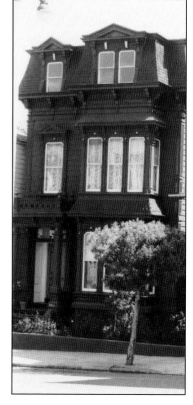

This is architect Charles Hinkel's house, built in 1885 at 280 Divisadero Street. The Hinkels were a prominent family of residential builders and developers for four generations. The Second Empire house with mansard roof cost $17,000 to build. There are not many mansard roofs in San Francisco, especially those with square bays, a portico with balustrade, and gingerbread details—all typical of a Hinkel-designed residence. San Francisco Landmark No. 190. (SFHC.)

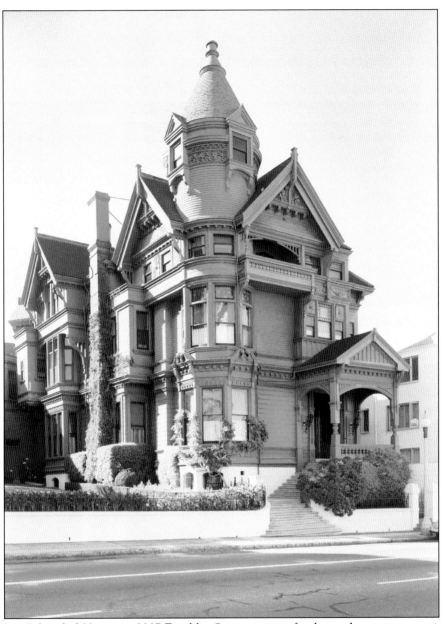

The Haas-Lilienthal House, at 2007 Franklin Street, is one of only two house museums in San Francisco. It was built around 1886 by architect Peter Schmidt for William Haas, a prominent businessman in early San Francisco. Born in Bavaria, he came to the United States in the 1870s. His youngest daughter, Alice, married Samuel Lilienthal. The Lilienthal family lived in the home from 1917 to 1972, when Alice passed away. The home was donated by the family to the Foundation for San Francisco's Architectural Heritage, which operates the property as a community trust open to the public for tours. The residence is considered to be a wonderfully preserved example of Queen Anne architecture and of upper-middle-class life in the Victorian era. The style features open gables, a turreted corner tower, and a witch's cap roof. Constructed of redwood and fir, it cost $18,500 to build. San Francisco Landmark No. 69, National Register No. 73000438. (LOC.)

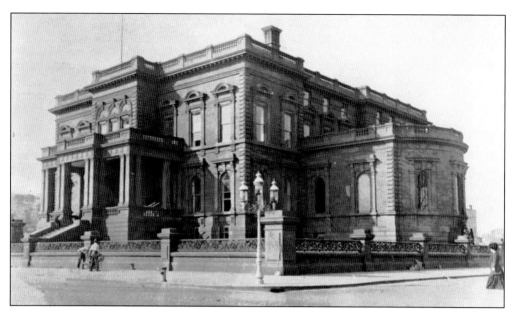

These photographs, taken from the same location about 30 years apart, depict the Flood Mansion turned Pacific Union Club. By 1940, the horse and carriage had been replaced by the automobile. The surrounding Nob Hill remained the center of San Francisco's high society. Saved by its brownstone walls, Flood Mansion, at 1000 California Street, was the only grand residence to survive the 1906 fire. Built in 1886 and designed by Augustus Laver, it was the residence of Nevada Comstock Lode tycoon James Flood. The Pacific Union Club purchased the shell after the 1906 disaster. Architect Willis Polk added a floor and semicircular wings; the building remains home to the Pacific Union Club. San Francisco Landmark No. 64, National Register No. 66000230. (Both, LOC.)

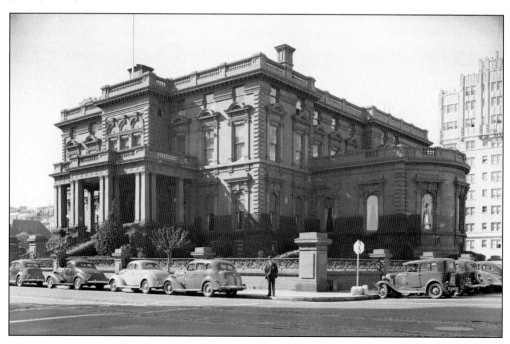

The Westerfeld House, at 1198 Fulton Street, was designed by Henry Geilfuss in 1889 for banker and candy baron William Westerfeld and built at a cost of $9,985. Years later, Russians purchased the house, although contrary to some accounts, it appears to have never been the home of the Russian consulate. It is now one of the best-known Victorian structures on Alamo Square near the famous Postcard Row at Steiner and Fulton Streets. San Francisco Landmark No. 135, National Register No. 89000197. (LOC.)

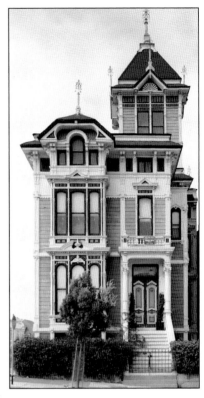

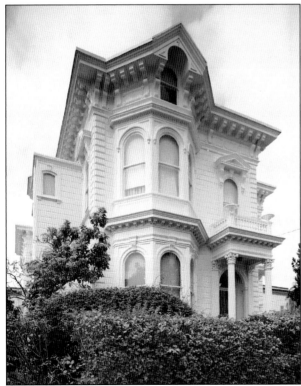

Built in 1870, the elegant Italianate Ortman-Shumate House, at 1901 Scott Street, is surrounded by a sizable garden, something rarely seen in San Francisco. In a 1978 oral history, Dr. Albert Shumate recalls that his grandfather had purchased several sections of property along Scott and California Streets for $5,000; this was one of the earlier plots purchased for what seemed like an enormous sum at that time. San Francisco Landmark No. 98. (LOC.)

Constructed around 1875, 43–45 Beideman Place, originally at 848 Octavia Street, is an example of Victorian Italianate architecture popular in San Francisco between the 1860s and 1880s. In 1974, it was hoisted onto a flatbed truck and moved to its current location, as preservationists rescued hundreds of Victorians from the wrecking ball. More than 350 Victorian homes were saved during the 1970s and 1980s. National Register No. 73000436. (SFHC.)

Historic records for this residence, at 1840 Eddy Street in the Western Addition, state it was moved in 1974 from 751 Turk Street in order to save it from demolition. Water Department records date the house to 1885, when it was owned by Martin O'Dea, a horseshoer. It is described as a Neoclassical Victorian with simple lines. National Register No. 73000437. (SFHC.)

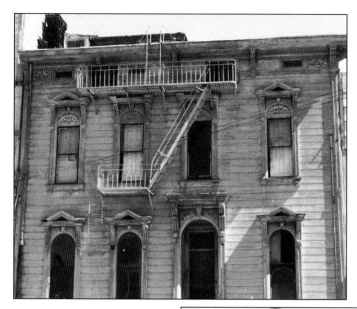

Constructed around 1875, 43–45 Beideman Place, originally at 848 Octavia Street, is an example of Victorian Italianate architecture popular in San Francisco between the 1860s and 1880s. In 1974, it was hoisted onto a flatbed truck and moved to its current location, as preservationists rescued hundreds of Victorians from the wrecking ball. More than 350 Victorian homes were saved during the 1970s and 1980s. National Register No. 73000436. (SFHC.)

Historic records for this residence, at 1840 Eddy Street in the Western Addition, state it was moved in 1974 from 751 Turk Street in order to save it from demolition. Water Department records date the house to 1885, when it was owned by Martin O'Dea, a horseshoer. It is described as a Neoclassical Victorian with simple lines. National Register No. 73000437. (SFHC.)

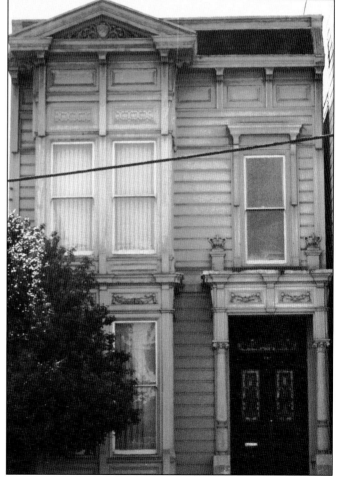

The Westerfeld House, at 1198 Fulton Street, was designed by Henry Geilfuss in 1889 for banker and candy baron William Westerfeld and built at a cost of $9,985. Years later, Russians purchased the house, although contrary to some accounts, it appears to have never been the home of the Russian consulate. It is now one of the best-known Victorian structures on Alamo Square near the famous Postcard Row at Steiner and Fulton Streets. San Francisco Landmark No. 135, National Register No. 89000197. (LOC.)

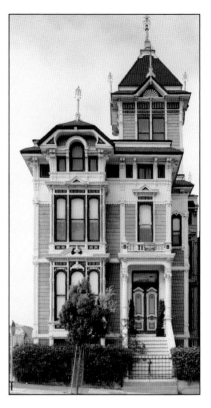

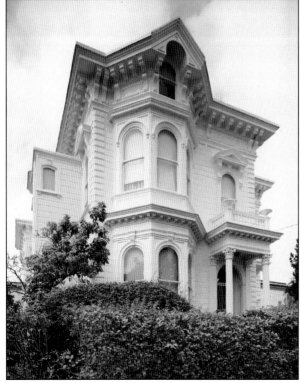

Built in 1870, the elegant Italianate Ortman-Shumate House, at 1901 Scott Street, is surrounded by a sizable garden, something rarely seen in San Francisco. In a 1978 oral history, Dr. Albert Shumate recalls that his grandfather had purchased several sections of property along Scott and California Streets for $5,000; this was one of the earlier plots purchased for what seemed like an enormous sum at that time. San Francisco Landmark No. 98. (LOC.)

The Leander Sherman House, at 2160 Green Street, was built in 1877 for the founder of the San Francisco piano store Sherman, Clay, & Company. Experts consider this Victorian Baroque residence one of the finest examples of Victorian structures in San Francisco. Musical artists such as Ignacy Paderewski and Madame Schumann-Heink performed in the skylit music and reception room. San Francisco Landmark No. 49. (SFHC.)

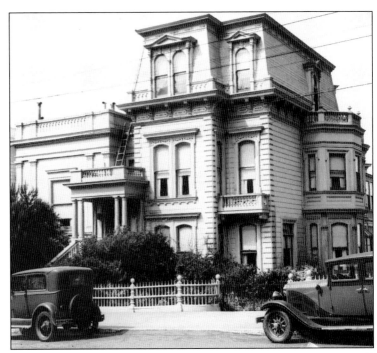

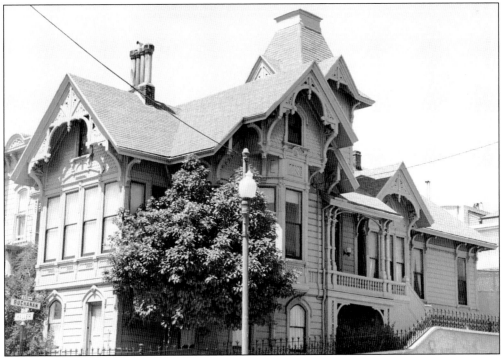

The Nightingale House, located at 201 Buchanan Street, is considered by experts to be a stellar example of the Eastlake Style, incorporating elements of Carpenter Gothic, Second Empire, and Italianate styles. It was built in 1882 for John Nightingale, former president of the California Pioneers and the realtor responsible for the construction of many Victorian houses in the neighborhood. San Francisco Landmark No. 47. (SFHC.)

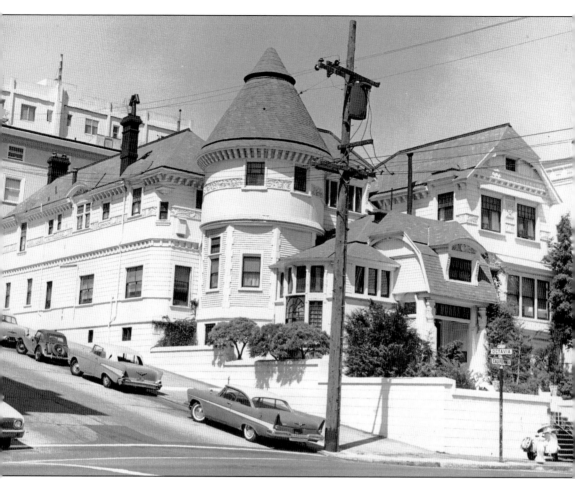

The Atherton House, at 1990 California Street, was built in 1881 for Dominga (Mrs. Faxon Dean) Atherton, mother-in-law of novelist Gertrude Atherton, after the death of Dominga's husband, for whom the town of Atherton, south of San Francisco, is named. In 1834, Faxon traveled to Chile to seek his fortune and married Dominga de Goñi. After her husband's death, Dominga moved to San Francisco with her son George and his wife, Gertrude. In 1887, George died of kidney failure on a trip to Chile, and sailors put his body into a barrel of rum, shipping it to the Atherton mansion, where George was given a proper burial. It is said his ghost now knocks about the house. In 1923, Carrie Rousseau purchased the mansion and lived there with her 50 cats until dying at the age of 93 in 1974. Stories abound that the house is haunted by four ghosts—those of George, Dominga, Gertrude, and Carrie. San Francisco Landmark No. 70, National Register No. 79000527. (SFHC.)

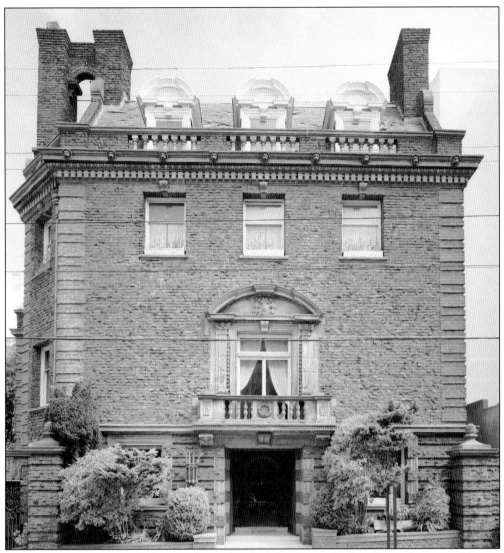

William Bourn (also spelled Bourne) was head of the Spring Valley Water Company, Empire Mine near Grass Valley, and Pacific Gas and Electric Company. Bourn helped finance the 1915 Panama-Pacific Exposition. In 1896, he asked Willis Polk to design his townhouse at 2550 Webster Street. This masonry masterpiece has elegantly carved ornamentations and is an impressive example of bricklaying and stonemasonry. Polk designed Bourn's offices and residence at Grass Valley's Empire Mine, as well as Filoli, Bourn's magnificent estate located in the city of Woodside on the San Francisco Peninsula. The estate is where the television series *Dynasty* was filmed. San Francisco Landmark No. 38. (LOC.)

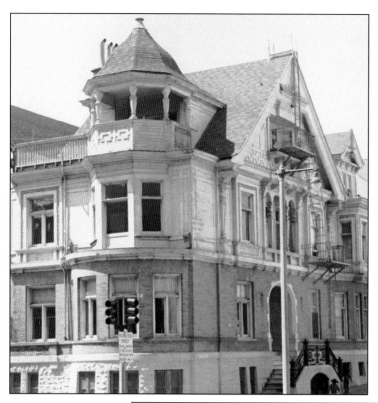

Architect William Curtlet designed this house at 301 Lyon Street for Thomas Clunie in 1897, when the surroundings were mostly sand dunes. No expense was spared, as there was even a telephone, which was a rarity at that time. The neighborhood would evolve into a prime residential area that included the Spreckles and Zellerbach family homes. Clunie was an attorney, real estate speculator, elected to the state senate, assembly, and Congress from the 1870s to the 1890s. San Francisco Landmark No. 128. (SFHC.)

In 1904, the William Haas family had architect Herman Barth design this Georgian-style brick residence at 1735 Franklin Street as a wedding present for their daughter Florine when she married Edward Bransten (né Brandenstein). Bransten's brother Max founded the MJB Coffee Company. San Francisco Landmark No. 126. (SFHC.)

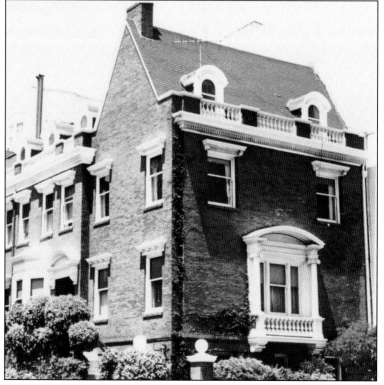

The 1906 earthquake and fire left hundreds of people homeless in San Francisco. These are two examples of temporary dwellings resulting from major destruction that took place. Note the sign on the right in the photograph at right that reads "Palace Hotel Grill" and the one in the photograph below that reads "House of Mirth." Some families who lost their homes were housed in Army tent cities and in 5,610 wooden cottages, most of them 10 feet by 14 feet. They were originally leased, and by 1908, some cottages had been purchased by individuals and moved to private lots. Approximately 24 survive, most unrecognizably altered, as is the case with the cottage located at 1227 Twenty-fourth Avenue. San Francisco Landmark No. 171. (Both, CAA.)

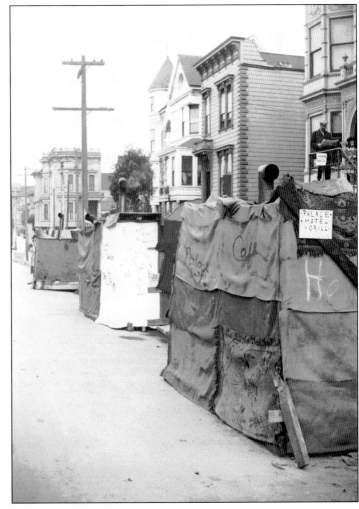

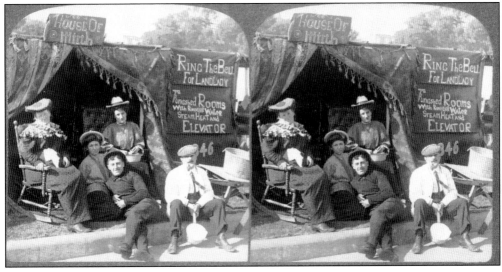

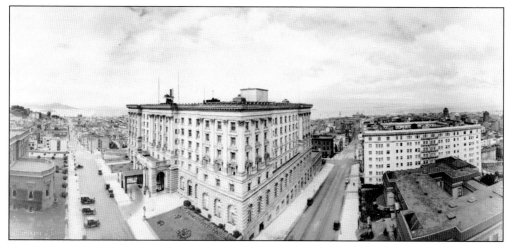

The Fairmont Hotel, 950 Mason Street, was created by Tessie Fair Oelrichs, the daughter of silver baron and senator James G. Fair. She chose Reid Brothers architects to design a 600-room hotel in the Beaux-Arts style. In 1906, before the hotel opened, Tessie exchanged it for other property with Herbert and Hartland Law. The 1906 earthquake and fire seriously damaged the Fairmont, but Herbert was determined to move forward and hired a young architect named Julia Morgan, with stunning results. The hotel's Venetian Room was popular through the 1940s into the 1980s, presenting entertainers such as Nat King Cole, Marlene Dietrich, and Joel Grey. The Venetian Room is most famous as the place in which Tony Bennett first sang "I Left My Heart in San Francisco." California Landmark No. 185, National Register 02000373. (Above, LOC; below, SFHC.)

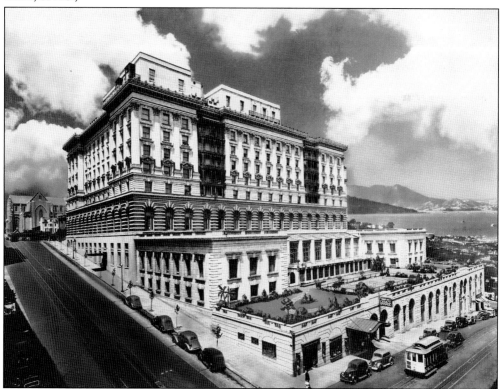

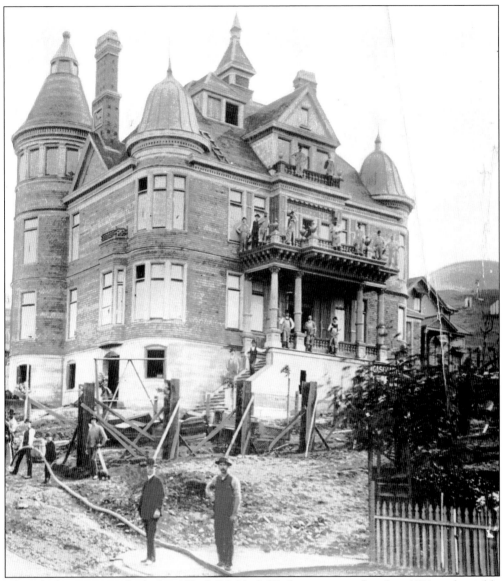

The Clarke Mansion, built for Alfred "Nobby" Clarke, was completed in 1891 and quickly acquired the name "Clarke's Folly." Clarke was considered a flamboyant and eccentric attorney who lived a colorful life. Born in Ireland, he became a sailor at a young age, sailing around Cape Horn in 1850 to wind up in Nevada County's goldfields and eventually in San Francisco, where he became a police officer and later an attorney. He was nicknamed "Nobby" because of an altercation with a seaman who savagely bit and disfigured his hand while he was in the line of duty. Nobby eventually purchased 17 acres of land in the city's Eureka Valley. Historical accounts indicate he spent $100,000 to build his mansion. Seen here is the construction crew posing for the photographer. In 1904, the structure was converted into the California General Hospital and later survived the 1906 earthquake. San Francisco Landmark No. 80. (SFHC.)

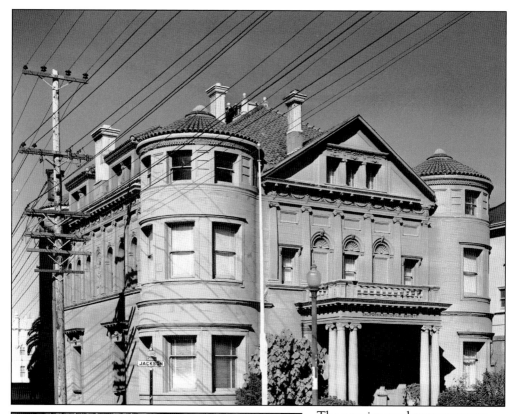

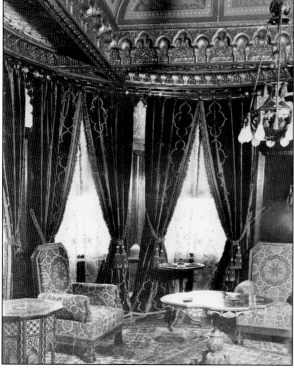

The massive sandstone structure at 2090 Jackson Street was built for William Franklin Whittier in 1894. A noteworthy example of Richardsonian Romanesque, with period styling, it is one of the few mansions to survive from the late 19th century to today. It was designed by Edward Swain and built at a cost of $152,000 for Whittier, the founder of the Fuller-O'Brien Paint Company. The image at left is of the parlor. The December 24, 1891, *San Francisco Chronicle* notes, "Edward R. Swain, the architect, has just completed the drawings and plans for the residence of W.F. Whittier, which is to be erected at the northeast corner of Jackson and Laguna Streets on a site commanding a magnificent view of the bay and the Golden Gate." San Francisco Landmark No. 75, National Register No. 76000524. (Both, LOC.)

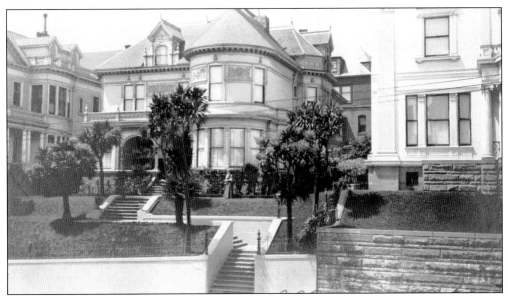

The Chambers Mansion was built in 1887 by prominent architects J.C. Mathews and Son for Richard Craig Chambers, one of the most powerful men in Utah. The residence was later altered by architect Houghton Sawyer at the direction of Chambers' two nieces after they inherited the property. One of the grand homes in San Francisco's Pacific Heights district, the mansion can be found at 2220 Sacramento Street. San Francisco Landmark No. 119. (SFHC.)

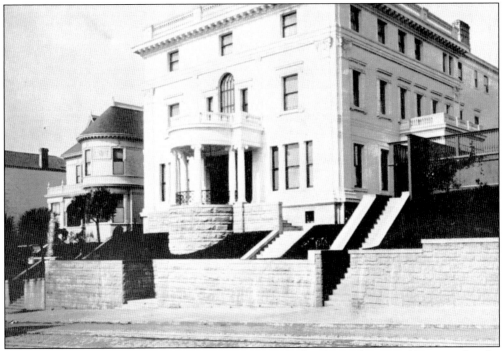

The Richard E. Queen House is the last architectural effort by Arthur Page Brown and is the only residence by this distinguished turn-of-the-century architect that remains. His work includes the Ferry Building. Queen moved into 2212 Sacramento Street in late 1896 and lived there the rest of his life. San Francisco Landmark No. 198. (SFHC.)

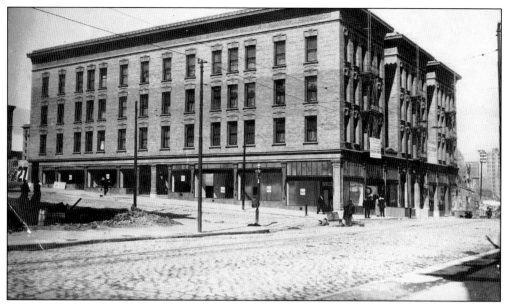

The Cadillac Hotel was designed by San Francisco architect Frederick H. Meyer in 1908 at 366–394 Eddy Street. Construction of the hotel brought residential development into the Tenderloin District neighborhood. The Cadillac became home to one of the oldest professional boxing establishments in the United States, Newman's Gym, which was located in a street-level space, originally the grand ballroom, from 1924 to 1984. San Francisco Landmark No. 176. (SFHC.)

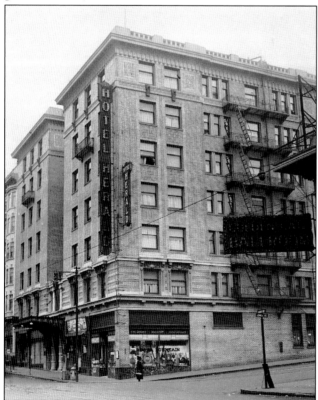

It was at 308 Eddy Street, in 1910, that architect Alfred Henry Jacobs designed the Herald Hotel. The brochure advertises, "A hotel of unusual merit . . . the most modern appliances as to lighting and sanitation . . . carefully planned, the fresh air and sunshine get into every nook and corner of its 150 rooms." According to the same brochure, a single room is $1 per night and $1.50 with a private bath National Register No. 82000985. (SFHC.)

The Mark Hopkins Hotel, designed by the firm of Weeks and Day in the Gothic Revival style popular in the 1920s, occupies the site of the Mark Hopkins Mansion, destroyed by the 1906 earthquake and fire. After the devastation as seen in the image below, the San Francisco Art Institute (sometimes called the Hopkins Art Institute) purchased the mansion from Edward Searles and built a modest structure in its place. Searles inherited the estate from Mary Hopkins upon her death. In 1925, George D. Smith, mining engineer and hotel investor, purchased and tore down the institute, replacing it with the luxury, 19-story Mark Hopkins Hotel at 850 Mason Street on Nob Hill and now home to the famous Top of the Mark. San Francisco Landmark No. 184. (Right, SFHC; below, LOC.)

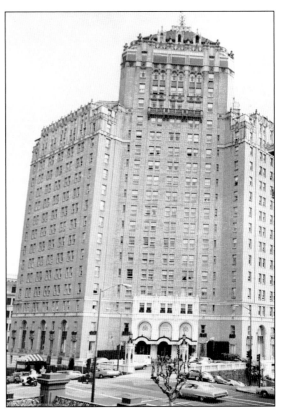

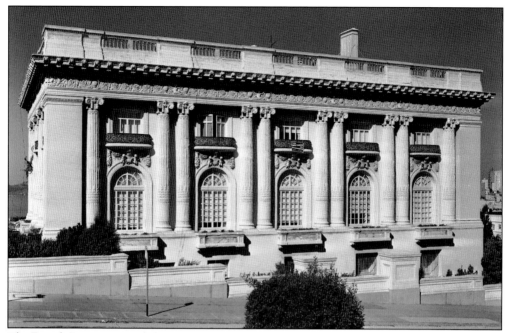

The French Baroque Spreckels Mansion was designed in 1912 for Adolph and Alma de Bretteville Spreckels by George A. Applegarth, a graduate of the École des Beaux-Arts in Paris. It was built at 2080 Washington Street at an estimated cost of $1 million. Adolph was the son of sugar tycoon Claus Spreckels. In order to accommodate this grand structure, Spreckels purchased and combined several lots with magnificent views of the bay and the Golden Gate Bridge. Alma Spreckels demanded that the existing Victorian houses, six on Jackson Street and two on Washington Street, be saved and moved to another location. Note the exquisite details of the frieze, cornices, and roof balusters. Each of the top-floor windows has a balcony with a scrolled metal balustrade. San Francisco Landmark No. 197. (Both, LOC.)

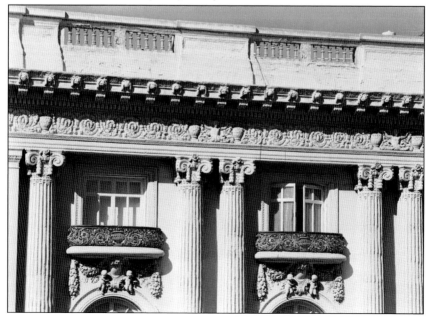

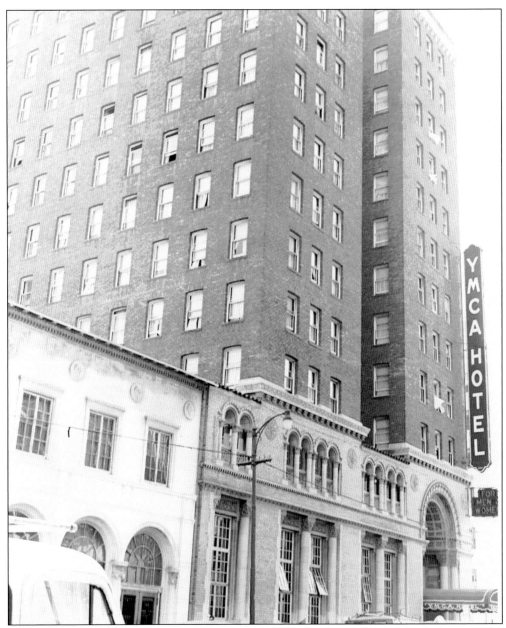

The Young Men's Christian Association (YMCA) Hotel is located at 351 Turk Street in the Tenderloin District of San Francisco. It was built in 1928 and became a popular residence with modest accommodations—436 rooms for men, women, and families. Rates were $1.25 to $1.75 per day. Historical records indicate the first YMCA in the United States opened in Boston, Massachusetts, founded in 1851 by Capt. Thomas Valentine Sullivan, an American seaman and missionary. He was inspired by the YMCA in London and saw an opportunity to offer a "home away from home" for young sailors on shore leave. National Register No. 86000148. (SFHC.)

Pictured above is the 965 Clay Street view of the Clay Street Center, designed by Julia Morgan in 1932 for the Young Women's Christian Association (YWCA). The 940 Powell Street portion now has 97 federally subsidized apartments for low-income elderly and disabled persons. Morgan chose to utilize both traditional Chinese and Tuscan designs in her architecture. The first woman ever admitted to the École des Beaux-Arts in Paris, she designed over 700 buildings in her 50-year career. The center was founded by missionaries and the Chinese community in order to provide social services. San Francisco Landmark No. 122. (SFHC.)

Two

BUSINESSES
WHERE PEOPLE WORKED

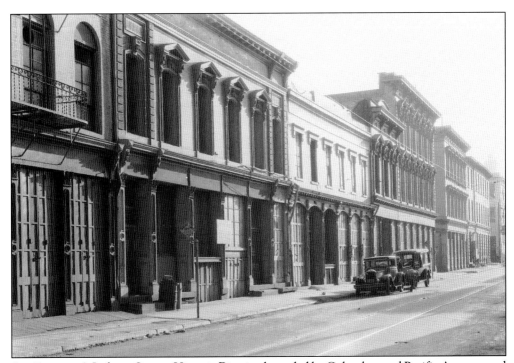

San Francisco's Jackson Square Historic District, bounded by Columbus and Pacific Avenues and Sansome and Washington Streets, contains almost all of the surviving commercial buildings from the 1850s and 1860s. As one of the primary central business districts of early San Francisco, Jackson Square's proximity to the original waterline enhanced the location's role in the development of the city's mercantile and financial enterprises. San Francisco Historic District, National Register No. 71000186. (LOC.)

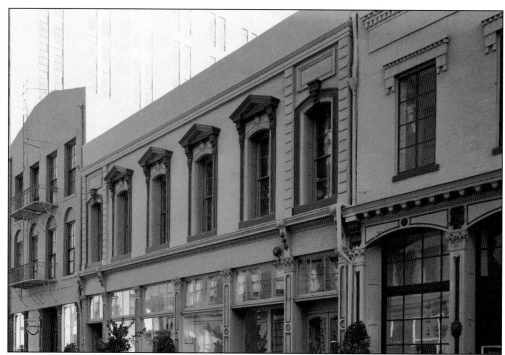

There are approximately 100 buildings in Jackson Square. Businesses in the area represented the whole spectrum of urban mercantile and social life, such as production and selling liquor, cigars, stoves, books, glassware, chocolate, and newspapers. Jackson Square developed quickly in Gold Rush days as an extension of the original commercial center at Portsmouth Plaza. The area was built on fill, which included abandoned ships that still lie under some of the buildings. (LOC.)

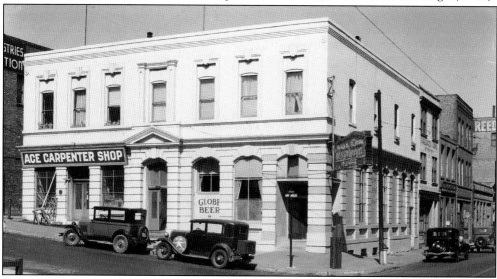

Future Civil War general William Tecumseh Sherman established the branch bank of Lucas, Turner, and Company in 1853, on the northeast corner of Jackson and Montgomery Streets. Built by Keyser and Brown and designed by architect Reuben Clark, it cost $53,000, a large sum for the day. It was one of the most important banks of the day. San Francisco Landmark No. 26, California Landmark No. 453. (LOC.)

The Hotaling Building, at 451 Jackson Street in Jackson Square, was built in 1866 by Anson Hotaling as the headquarters for his several business interests, which included liquor and real estate. The building also housed Hotaling's impressive collection of books and paintings. A well-known survivor of the great earthquake and fire, the Italianate facade is cast iron with cast iron shutters typical of fire-resistant construction. Note the striking detail around the door. San Francisco Landmark No. 12. (Both, LOC.)

Hotaling Annex West, at 463–473 Jackson Street, was built in the Italianate style of the 1860s. Dominick Small, a carpenter and builder, had his shop in the structure in the late 1870s. Anson Parsons Hotaling bought the building before 1890 for his liquor business, and his estate owned it until 1944. The Works Progress Administration (WPA) rented the building during the 1930s for the Federal Writers and Federal Artists projects. During World War II, the tenants included Giacomo Patri, Avrum Rubinstein, and Byron Randall. San Francisco Landmark No. 20. (LOC.)

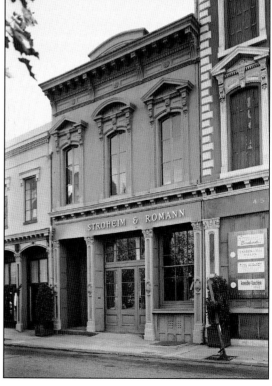

Hotaling Annex East, at 445 Jackson Street, was built in 1866 in Jackson Square. Originally housing the Tremont Stables, which served the nearby Tremont Hotel until 1870, the building was later purchased by Anson Parson Hotaling to warehouse his whiskey business. San Francisco Landmark No. 13. (LOC.)

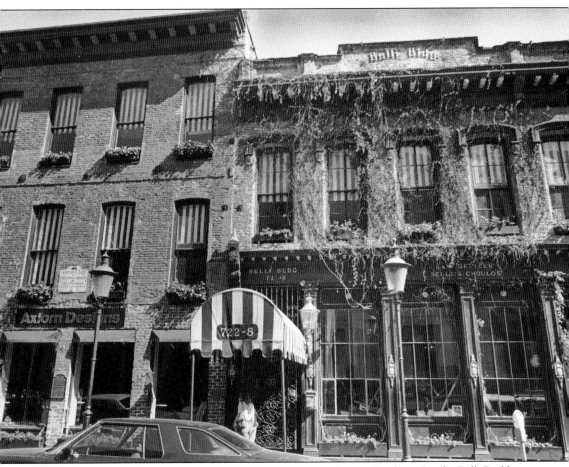

These two buildings share the address 722–728 Montgomery Street. On the right, the Belli Building was originally constructed in 1849, destroyed by fire in 1851, and immediately rebuilt using the old walls and foundations. Built upon the original raft of planks six to eight inches thick, and to a depth of eight feet, it was laid as a foundation in the mud of what was then Yerba Buena Cove. It is said that the tides still rise and fall in the elevator shaft. At one time, it was the Melodeon Theatre where Lotta Crabtree performed. The adjacent Genella Building was constructed in 1853 by Joseph Genella as his residence and location for his china and glassware company. The site was the location of the first Masonic lodge meeting in San Francisco in 1849. The upper floor was used as a meeting hall for the Independent Order of Odd Fellows (IOOF), later by the ancient Jewish order Kesher Shel Barzel (KSB), and then by the American Protestant Association (APA). It also housed a bathhouse, a puppet theater, and a garment factory before being restored in the 1950s. Left, San Francisco Landmark No. 10; right, San Francisco Landmark No. 9. (SFHC.)

The Medico-Dental Building, at 441 Jackson Street, was constructed in 1861 on top of two ships abandoned during the Gold Rush. It was built as a warehouse for wine, tobacco, and coffee. San Francisco Landmark No. 14. (LOC.)

Parts of Jackson Square were built at the shoreline on landfill. Occasionally, structures were built on the hulls of abandoned ships, as was the case with the storeship *Apollo* at the northwest corner of Sacramento and Battery Streets. A newspaper article of the day reads: "Among the rotting timbers were coins of 1840, an American penny of 1825, a British penny of 1797." The *Apollo* still lies at the site. National Register No. 91000561. (SFHC.)

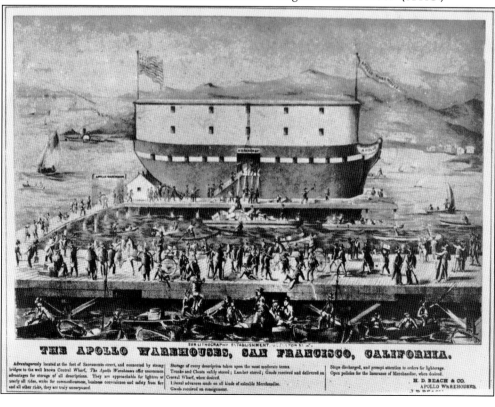

THE APOLLO WAREHOUSES, SAN FRANCISCO, CALIFORNIA.

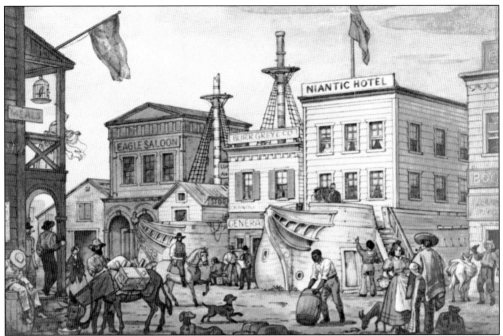

The ship *Niantic* arrived from Panama in San Francisco Bay in the summer of 1849. After depositing 248 gold-seekers, the ship was beached at the corner of Clay and Sansome Streets. That would be when the shoreline reached further inland. The hull was divided into warehouses, entered by doorways on the sides. Serving as a storeship, it earned $20,000 per month until burning down to the hulk in the San Francisco fire of May 1851. This hulk was used as the foundation for the Niantic Hotel, a famous hostelry until 1872. It is the furthest inland of the 44 ships thought to be buried in downtown San Francisco. California Landmark No. 88, National Register No. 91000563. (Both, LOC.)

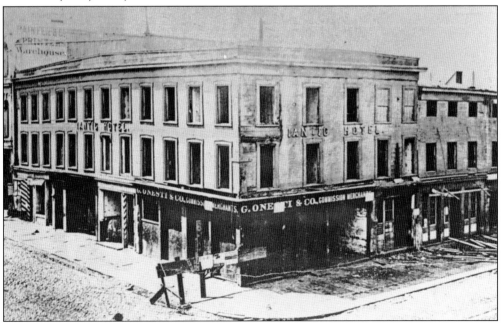

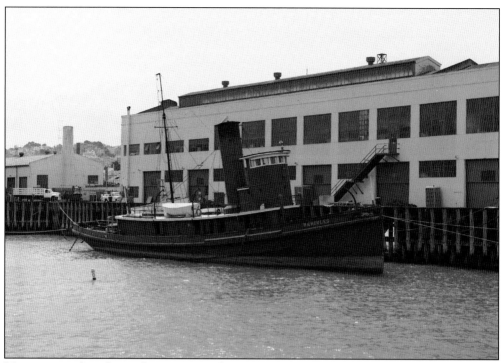

Historic records indicate the 1907 *Hercules* was considered state-of-the-art among the steam-powered tugboats of its day. A well-preserved model of 20th-century tugboats, it floats at the Hyde Street Pier. The boat traveled through the Straits of Magellan, towing sailing vessels and large disabled ships. National Register No. 75000225. (LOC.)

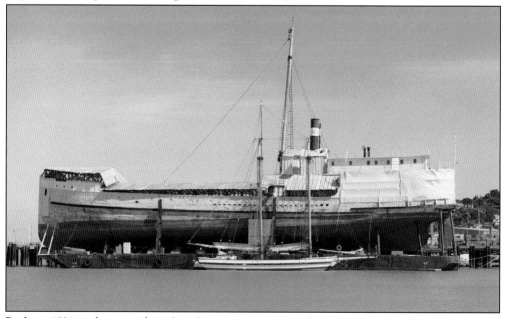

Built in 1891 and operated on San Francisco Bay, the *Alma* scow schooner is considered an outstanding example of a vessel once commonly found on American waterways. No other scow schooner is thought to have survived afloat. National Register No. 75000179. (LOC.)

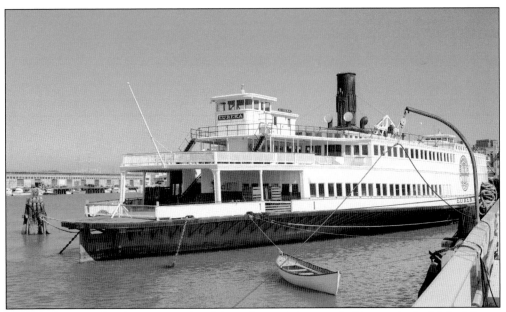

The *Eureka* steam ferryboat is considered the only surviving vessel of its type in the United States and symbolizes an era of travel that has all but vanished from American waters. The boat was originally named the *Ukiah* and was built in 1890 by the San Francisco and North Pacific Railroad Company at its Tiburon Yard. In operation through 1920, it carried railroad cars and passengers until it was virtually completely rebuilt under the name *Eureka*, lengthened and made ready for carrying automobiles and passengers until 1941. Made almost entirely of Douglas fir, it now rests at the Hyde Street Pier at Aquatic Park. National Register No. 73000229. (Both, LOC.)

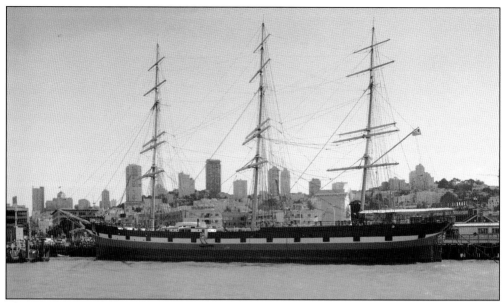

The National Park Service website states, "On January 15, 1887, with a twenty-six-man crew, *Balclutha* sailed from Cardiff, Wales, on her maiden voyage. She was bound for San Francisco. The ship entered the Golden Gate after 140 days at sea, unloaded her cargo of 2,650 tons of coal, and took on sacks of California wheat. . . . She arrived with a cargo three times, but also brought pottery, cutlery, Scotch whisky (from Glasgow and Liverpool) and 'Swansea general' (tinplate, coke, and pig iron) to San Francisco." National Register No. 76000178. (LOC.)

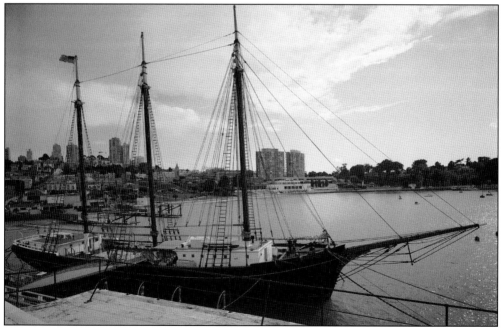

The C.A. *Thayer* is a wooden-hulled, three-masted schooner designed for carrying lumber. Built in 1895 in Fairhaven, California, the hull was made of Douglas fir. Later, the *Thayer* worked in the fishing and salting industry. This ship has been afloat for over 110 years, has made over 100 voyages, and now rests at the Hyde Street Pier. National Register No. 66000229. (LOC.)

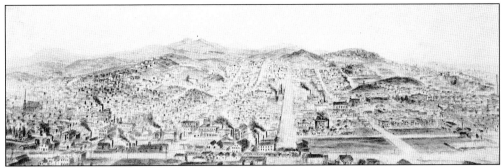

The Dogpatch Historic District—bounded by Mariposa, Tubbs, Third, and Indiana Streets—was the location of industrial and commercial buildings between 1870 and 1930. It was the most industrialized area of the city and was the center of heavy industry in the western United States for over 100 years. Ships were built there, and the Pacific Rolling Mills produced mining machinery, rail equipment, and locomotives. (LOC.)

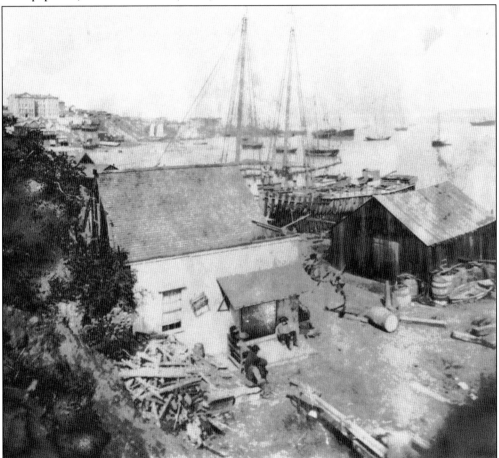

San Francisco's South Beach area is seen here from Steamboat Point. South Beach was adjacent to what is now the South End Historic District. South End was significant between the years 1865 and 1935, during which the city's waterfront area became an important part of American maritime industries. This district has a large concentration of buildings dating from the 19th and 20th centuries, primarily brick and concrete warehouses. (LOC.)

In 1884, the San Francisco Gas Light Company purchased three blocks bounded by Webster, Laguna, Buchanan, and Bay Streets, and in 1891, construction began on this building at 3640 Buchanan Street, designed by Joseph B. Crockett. Back in 1906, refugees from the great earthquake found sanctuary in and around the building and grounds. In the 1950s, Pacific Gas and Electric closed the plant. San Francisco Landmark No. 58. (SFHC.)

Pictured here is the Hunters Point Springs–Albion Brewery, at 881 Innes Avenue, established in 1879 by John Hamlin. He found underground springs beneath the property. Some historic accounts attribute the construction style to the Norman castles of England. The original buildings were built by English stonemasons using rock from nearly Bayview Hill. San Francisco Landmark No. 60. (SFHC.)

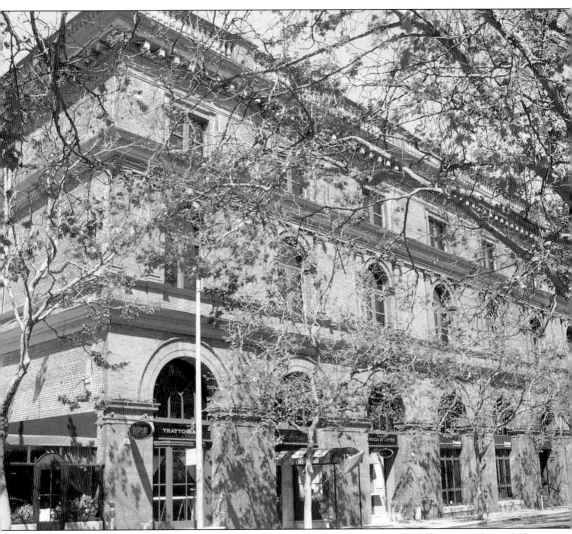

This Italian Swiss Colony Warehouse was designed by Hemenway and Miller in 1903 at 1265 Battery Street. It is considered one of the best examples of warehouse architecture in San Francisco. The Italian Swiss Colony Winery was founded in 1881 in Asti, California, about 80 miles north of San Francisco. The site of the actual winery is California Landmark 621 and is where, in 1881, Italian Swiss immigrants established an agricultural colony. The wines were produced from Old World grape plants and won so much praise in the New World that by 1905, ten gold medals had been awarded to Italian Swiss Colony. The author's grandfather was one of first Italian immigrant workers at the Asti Italian Swiss Colony vineyards, traveling to California in the 1800s. San Francisco Landmark No. 102. (CAA.)

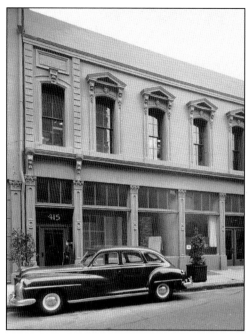

Domingo Ghirardelli opened his first San Francisco chocolate factory in 1853 on the first floor of this Italianate building. He and his family lived on the second floor. In 1894, he moved his business to a large waterfront factory, which today bears his name. Printed on the back of the photograph is the following: "Survivor of the 1906 fire. This building at 415 Jackson Street was the location of one of the telephones connected to the first telephone exchange. The subscriber was listed as Ghirardelli & Danzel, Coffee & Spice." The photograph below is of the Pioneer Woolen Mills and Domenico Ghirardelli Company at 900 North Point Street. Designed by Swiss architect William Mooser in 1864, it is one of the oldest buildings in San Francisco. Uniforms for Union soldiers were manufactured there. San Francisco Landmark No. 15, National Register No. 82002249. (Left, SFHC; below, LOC.)

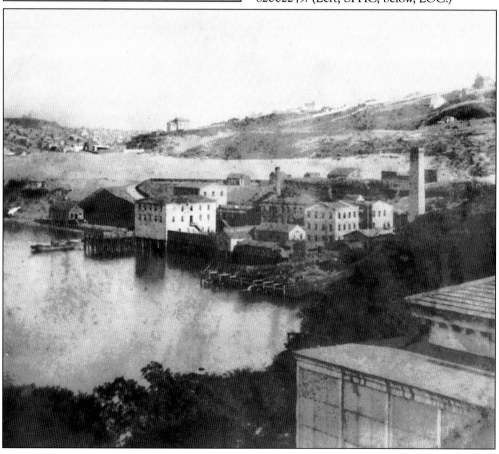

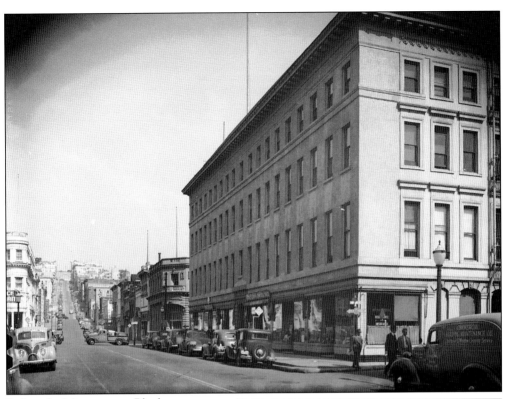

Before the Montgomery Block was demolished in 1959 and eventually replaced by the Transamerica Pyramid, it stood here at 600 Montgomery Street. The Montgomery Block was conceived by Henry Wager Halleck and English-trained architect Gordon Parker Cummings. Considered fireproof and the safest and largest office building of its time, it became the center of the city's commercial life. The favorite office space of professional men from 1853 and 1890, it housed the Adolph Sutro Library and the domicile of artists and writers, such as George Sterling Maynard Dixon and Jack London. The only major downtown building to survive the 1906 disaster, it had a U shape around a court with interior hallways lighted by skylights and open wells. California Landmark No. 80. (Both, LOC.)

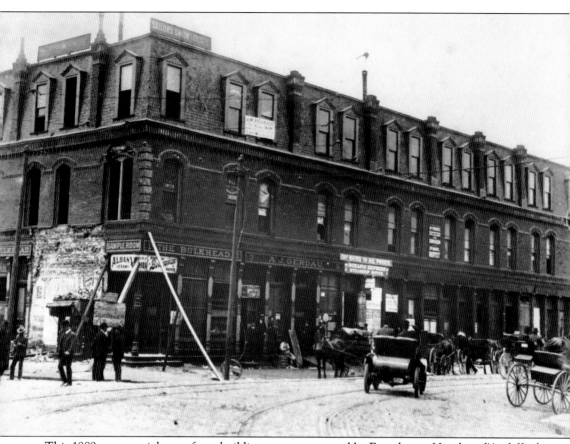

This 1889 commercial waterfront building was constructed by Frenchman Hipolyte d'Audiffred in a Parisian style at 1–21 Mission Street near the Embarcadero. It is said to be one of the few structures to survive the 1906 fire, and, according to urban legend, the keeper of the Bulkhead offered the dynamite crew a horse cart full of wine and two quarts of whiskey each if they could save the building. The nautical ornamentation on the ground floor cornice is a reminder that the bay once came right near the door. Saloons continued to operate on the ground floor for years, while the upper floors served as rooms for sailors and space for artists and musicians. San Francisco Landmark No. 7, National Register No. 79000528. (LOC.)

The 1890 Mills Building, at 2220 Montgomery/220 Bush Streets, was the first steel-frame building and, for many years, one of the tallest buildings in San Francisco. Designed by Burnham and Root, it is the only intact example of Chicago School architecture in the city. The adjoining Mills Tower, designed by Lewis Hobart in 1932, was named after its builder, prominent businessman Darius Ogden Mills. San Francisco Landmark No. 79, National Register No. 77000334. (LOC.)

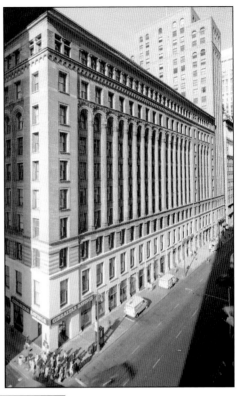

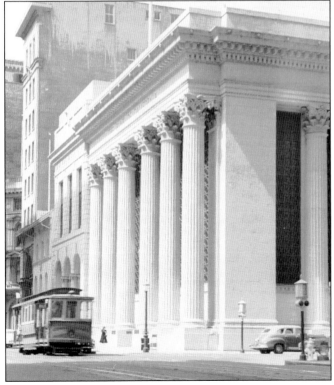

The original Bank of California was built at this site, 400 California Street, founded by Darius Ogden Mills and William Chapman Ralston in 1864. That original structure was demolished to make way for this version. The Bank of California is the oldest incorporated commercial bank in the state. San Francisco Landmark No. 3. (SFHC.)

55

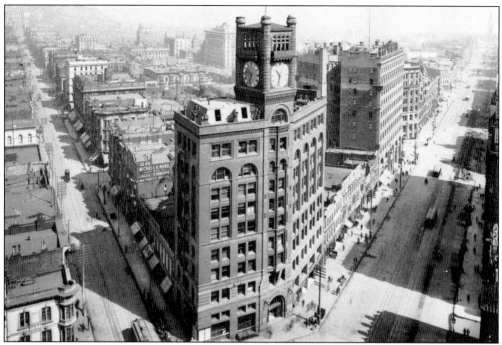

Back in 1889, this structure was San Francisco's first skyscraper. Built of sandstone and brick, it was also the tallest building on the West Coast. The Chicago architectural firm of Burnham and Root designed it for the *San Francisco Chronicle* in the Richardson Romanesque style. Located at 690 Market Street, it shares a corner with the Hearst and Call Buildings. San Francisco Landmark No. 243. (SFHC.)

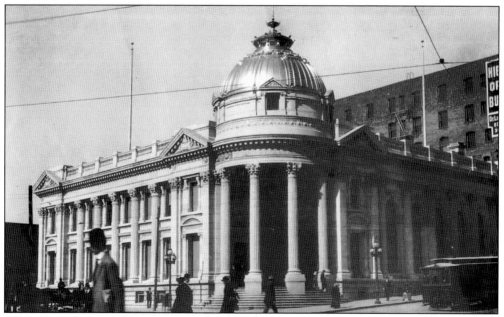

Albert Pissis designed this magnificent bank at One Jones Street at Market, the oldest Classical Revival–style bank in San Francisco. Built in 1892, the Hibernia Bank structure has existed for more than 150 years in the city. San Francisco Landmark No. 130. (SFHC.)

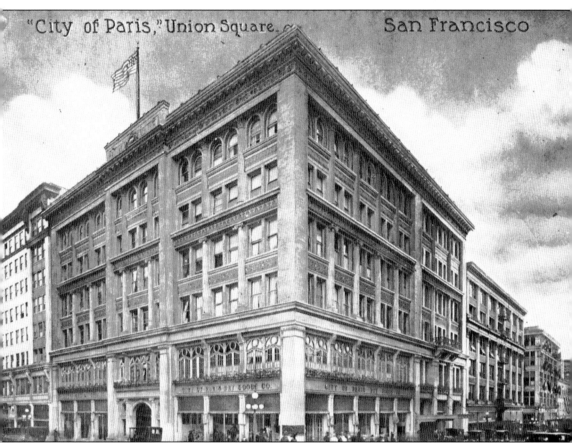

"City of Paris," Union Square. San Francisco

It was 1850 when the Verdier brothers, immigrants from France, opened a store aboard the ship *La Ville de Paris* to serve the argonauts passing through San Francisco's harbor. In 1896, the business moved into a new building designed by architect Clinton Day. Damaged by the 1906 earthquake, its interior was reconstructed by architects John Bakewell and Arthur J. Brown. The old City of Paris Building was one of the finest examples of a Beaux-Arts–style commercial building in California. In 1981, the City of Paris Building at 181–189 Geary Street at Stockton Street was both a National Register landmark (No. 75000471) and California historical landmark (No. 876). Sadly, that was not sufficient to save it from demolition by Neiman Marcus. Pressured by preservationists, the firm at least salvaged and restored the glass dome and parts of the rotunda. (LOC.)

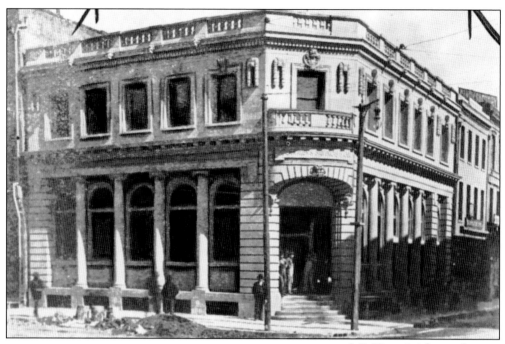

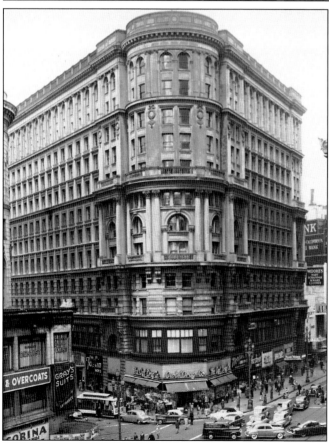

A.P. Giannini, born of Italian immigrants, started working at age 14, and by the age of 32, he was on the board of the Columbus Savings and Loan Society/ Columbus Savings Bank. 700 Montgomery Street was built to house the bank in 1904. San Francisco Landmark No. 212. (SFHC.)

In 1902, James L. Flood, heir to a Comstock silver fortune, purchased the land beneath the fire-damaged Baldwin Hotel. He hired Albert Pissis to design the Classical Revival–style Flood Building, costing $1,500,000, a huge amount at that time. The 1906 earthquake and fire only damaged the first two floors—credited to the steel support system— that were soon repaired. The massive, 12-story building stands at 870–1898 Market Street. San Francisco Landmark No. 154. (SFHC.)

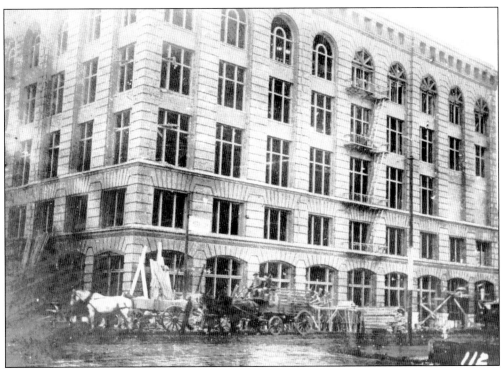

In the late 1890s and early 1900s, the Folger Coffee Company was the oldest family-owned coffee importer in San Francisco. In 1915, during the Panama-Pacific Exposition, the company introduced Central American beans to the Bay Area. Henry Schulze was the architect responsible for 101 Howard Street back in 1905. Originally, it served as office space, processing plant, and warehouse. National Register No. 96000679. (SFHC.)

This Romanesque Revival–style building was designed by George Kelham as the Hills Brothers Coffee Plant in 1926. It occupies 2 Harrison Street near San Francisco's Embarcadero. Hills Brothers was established in 1878 and was one of several large coffee plants originating in San Francisco, among them Folgers, MJB, and Schilling. San Francisco Landmark No. 157. (SFHC.)

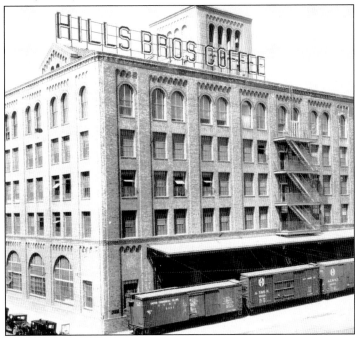

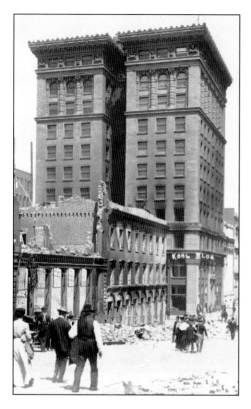

The Alvinza Hayward Building, also known as the Kohl Building, was built in 1901 of limestone and brick over a steel frame. Located at 400 Montgomery Street, it survived the 1906 fire and serves as a good example of early fireproof construction. San Francisco Landmark No. 161. (SFHC.)

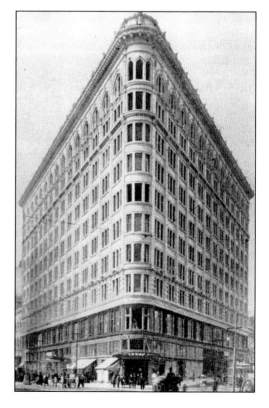

The original Phelan Building was destroyed in 1906 and was replaced by this structure in 1908 at 760–784 Market Street. It quickly became one of the most prominent and important office buildings in San Francisco. Considered a splendid example of the City Beautiful movement, it was constructed with glazed cream terra-cotta. San Francisco Landmark No. 156. (SFHC.)

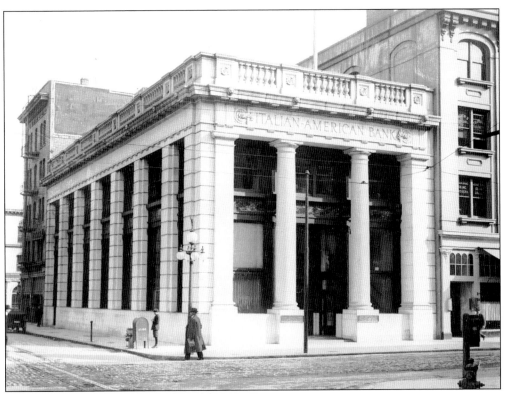

The 1907 Italian American Bank Building, designed by John Galen Howard, is considered an excellent example of a style common at that time, which resembles that of an ancient temple. Steel-frame concrete construction and granite Tuscan style columns, highlight this lovely structure at 460 Montgomery Street. This and the adjacent Borel building were virtually demolished to make way for a high-rise office building. Both original buildings were designated landmarks at the time. San Francisco Landmark No. 110. (SFHC.)

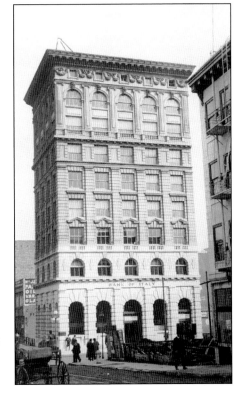

The National Register statement of significance for the Bank of Italy reads: "From 1908 to 1921, this eight story, Second Renaissance Revival structure in San Francisco's financial district served as headquarters for Bank of Italy (later renamed Bank of America). Amadeo Pietro Giannini built the bank on bay fill in Yerba Buena Cove at the spot where Captain Montgomery landed in 1846. It stands at 552 Montgomery Street." A California Historical Landmark plaque is set in the base of the building, marking the site at the corner of the intersection with Clay Street. California Landmark No. 81, National Register No. 78000754. (SFHC.)

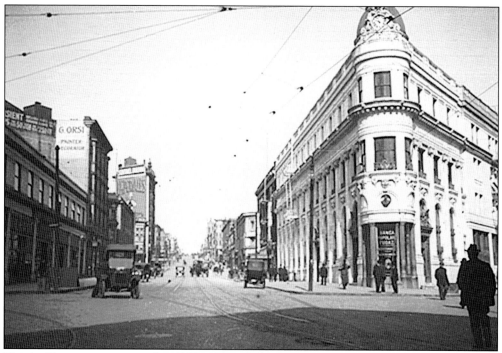

This building was constructed in 1909, at Four Columbus Avenue, for Il Banco Populare Italiano Operaia Fugazi, founded by John F. Fugazi, immediately after the 1906 disaster. It was eventually acquired by the Bank of Italy, which later became the Bank of America and then, in 1938, became the Transamerica Corporation. The original design by Charles Paff has been redesigned several times. San Francisco Landmark No. 52. (JBM.)

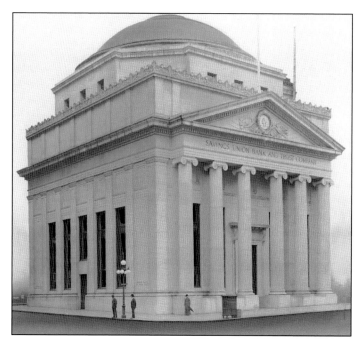

The Savings Union Bank Building, at One Grant Avenue, was designed in 1910 by Walter Danforth Bliss and William Baker Faville. Between 1898 and 1925, Bliss and Faville were responsible for many of San Francisco's most imposing buildings. The bank and several other handsome structures in the area combine at One Grant Avenue to form a striking gateway to Grant Avenue. San Francisco Landmark No. 132. (SFHC.)

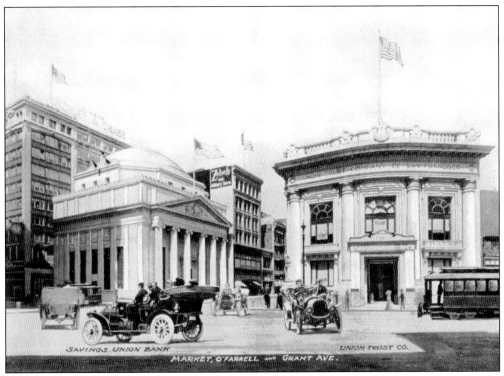

Architect Clinton Day was responsible for the Union Trust Bank at 744 Market Street, a prominent location in San Francisco's downtown business district. Day also designed the City of Paris Department Store; both were designed in 1910. San Francisco Landmark No. 131. (SFHC.)

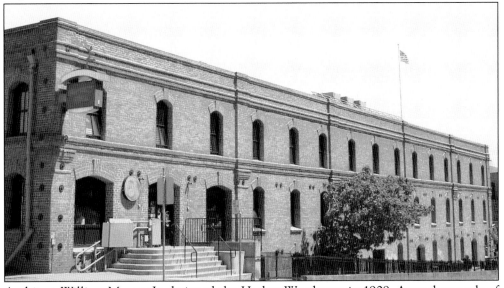

Architect William Mooser Jr. designed the Haslett Warehouse in 1909. A good example of 19th-century warehouse design, it was built for the California Fruit Cannery Association, later renamed Del Monte. Its prime waterfront location at 680 Beach Street probably saved it from the wrecking ball all these years. San Francisco Landmark No. 59, National Register No. 75000172. (CAA.)

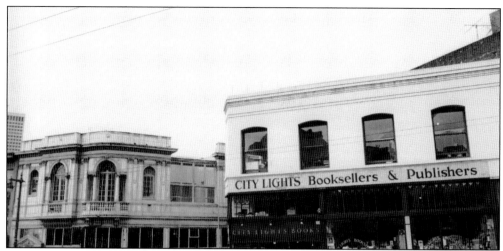

San Francisco's literary icon, City Lights Bookstore, is at 261 Columbus Avenue, designed by Oliver Everett in 1907. In 2001, the San Francisco Board of Supervisors designated City Lights a local landmark, the first time landmark status was bestowed on a business rather than a building. Described as "playing a seminal role in the literary and cultural development of San Francisco and the nation", it was the nation's first all-paperback bookstore, founded in 1953 by poet Lawrence Ferlinghetti and Peter D. Martin. San Francisco Landmark No. 228. (CAA.)

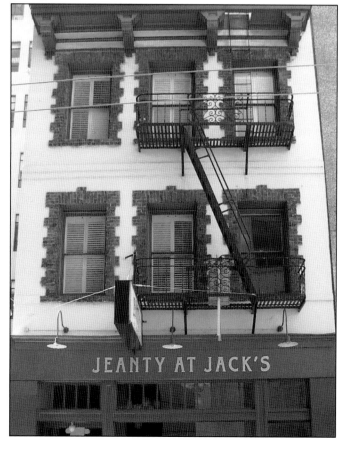

Abraham Lincoln was president and the United States was in the Civil War when people were dining at Jack's Restaurant. It was opened in 1864 by Frenchman George Voges, and urban legend says it was named after the wild jackrabbits in the neighborhood. Heads of state, writers, and famous actors, including Cary Grant and Clark Gable, enjoyed Jack's. The second-floor rooms were at one time part of a popular bordello. San Francisco Landmark No. 146. (CAA.)

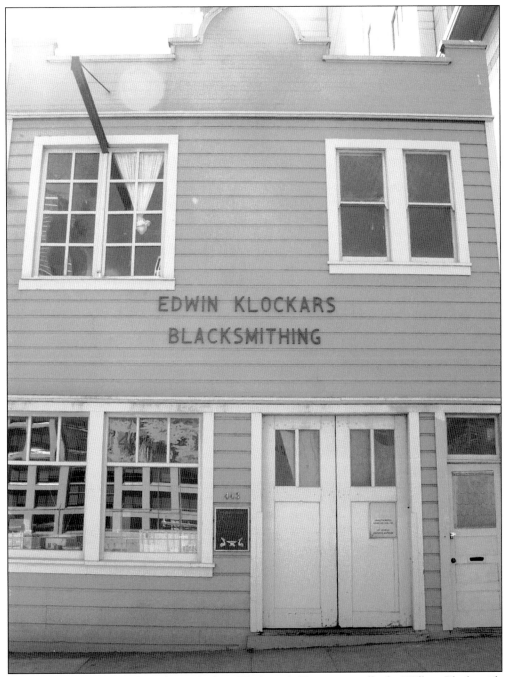

A plaque on the front of the Edwin Klockars Blacksmith Shop, originally the Wilbert Blacksmith Shop, reads, "Beginning in the 1860s, foundries south of Market Street fabricated mining machinery, railroad cars, and ships. This shop at 443 Folsom Street, is the last. Fred V. Wilbert forged fine tools, Edwin A. Klockars (1898–1994), a native of Munsmo, Finland, joined Wilbert in 1928. His precision-made tools helped construct the Golden Gate Bridge and hundreds of ships during World War II. . . . Ed Klockars had one motto: Anything you need, we make. This shop still does." San Francisco Landmark No. 149. (CAA.)

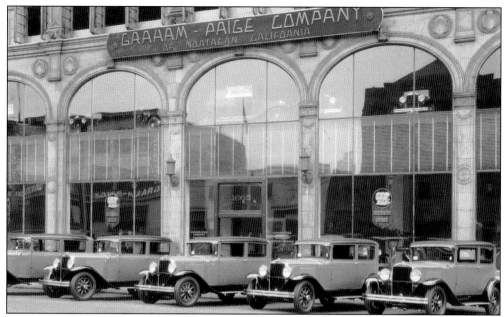

The Paige Motor Car Company Building, designed by Sylvain Schnaittacher, is one of the few remaining lavish motorcar company buildings on Van Ness Avenue's automobile row. These extravagant automobile showrooms were built during the mid- and late 1910s. The Paige Motor Car Company Building was constructed in 1912 at 1699 Van Ness Avenue. National Register No. 83001234. (SFHC.)

The Flatiron Building at 540–548 Market Street, at the intersection of Market and Sutter Streets, was designed by Havens and Toepke and built in 1913. Flatiron buildings, so named because they resembled clothes irons of the period, are among the earliest skyscrapers erected in such North American cities as New York City, Chicago, and San Francisco. San Francisco Landmark No. 155. (SFHC.)

Willis Polk was an important architect in the rebuilding of the city after 1906, and it is said, the Hobart Building at 582–592 Market Street, was one of his favorites. A very well-received building when constructed in 1914, it occupies an important place on Market Street. San Francisco Landmark No. 162. (SFHC.)

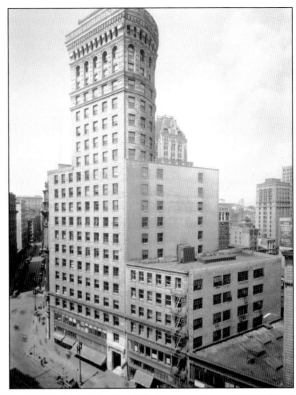

The San Francisco Labor Temple, also known as the Redstone Union Building, was built in 1914 at 2926–2948 Sixteenth Street and designed by architect Mathew O'Brien. The building was occupied by the San Francisco Labor Council, labor union offices, and meeting halls. Considered the center of the city's historic labor community for over 50 years, it played an important role in the 1934 citywide labor strike. San Francisco Landmark No. 238. (SFHC.)

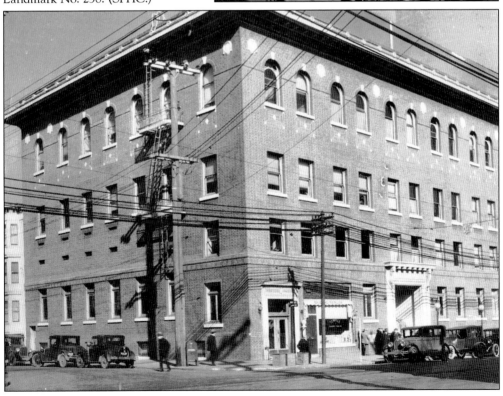

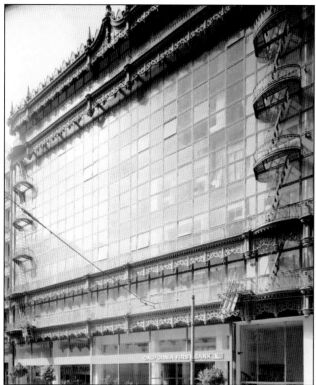

This innovative cast iron tracery, glass-walled structure is the Hallidie Building. As it stands at 130 Sutter Street, the impressive facade has captivated people for over 95 years. Constructed in 1917 and designed by Willis Polk, it is one of the most recognizable structures in San Francisco's Financial District. It was named for cable car inventor Andrew S. Hallidie. San Francisco Landmark No. 37, National Register No. 71000185. (LOC.)

Frank Lloyd Wright's talents as a preeminent architect are showcased in the V.C. Morris Gift Shop at 140 Maiden Lane. Vere Chase Morris commissioned Wright to build a home in San Francisco's Sea Cliff district, but that project was cancelled, so Wright designed this shop to sell china, linens, silver, and glassware. Considered one of San Francisco's most important modern buildings, it was constructed in 1948 as an alteration to an existing 1911 warehouse. San Francisco Landmark No. 72. (LOC.)

This majestic clock graces the sidewalk in front of Samuels Jewelers. This stunner was designed and built by Albert S. Samuels in 1915, in collaboration with mechanical engineer Joseph Meyer. It was here, at 856 Market Street, that author Dashiell Hammett worked during his days in San Francisco. San Francisco Landmark No. 77. (SFHC.)

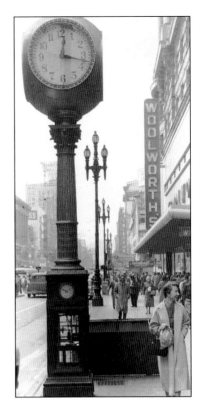

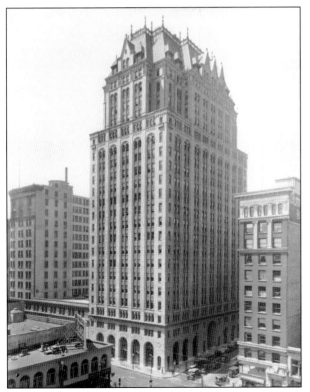

The Hunter-Dulin Building was West Coast headquarters for the National Broadcasting Company from 1927 to 1942. Architects Schultze and Weaver designed the 25-story structure at 111 Sutter Street. It was built on the site of the demolished Lick Hotel, owned by millionaire James Lick. The firm of Hunter, Dulin, and Company purchased the property in 1925 for a price in excess of $1 million. The building's most famous "tenant" was Dashiell Hammett's famous detective Sam Spade. National Register No. 97000348. (SFHC.)

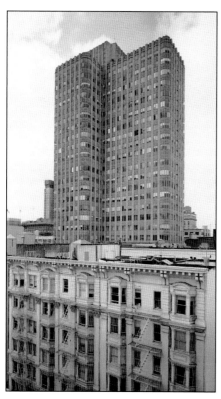

In 1929, this magnificent early San Francisco skyscraper was built at 450 Sutter Street. Architects Miller and Pflueger used a Mayan-inspired decorative theme for 26 stories of medical office space. The structure has continued to offer a prestigious office address for over 87 years. Both at a distance and from across the street, the intricate work on the windows and entrance is quite stylish. The lobby, with dark red marble walls, envelopes the public them in a serenely elegant space. National Register No. 09001118. (Both, LOC.)

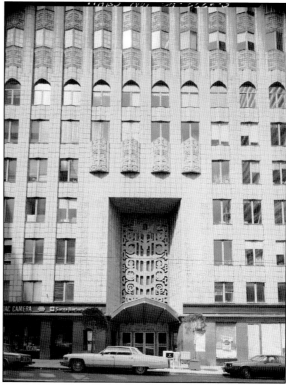

Three

RECREATION AND ENTERTAINMENT
WHERE PEOPLE FROLICKED

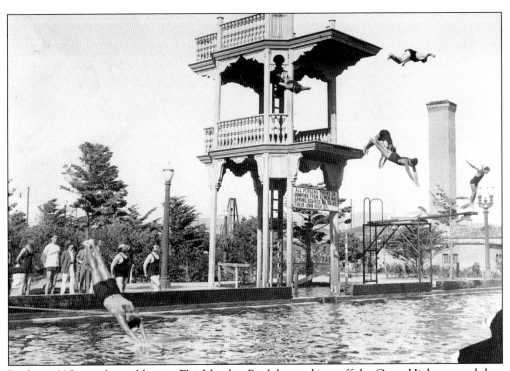

Back in 1925, people could enjoy Fleishhacker Pool, located just off the Great Highway, and they did so for 47 years. One of the favorite attractions was this popular diving structure. Bathers could frolic in 6,500,000 gallons of salt water pumped from the Pacific Ocean in a pool that measured 1,000 feet by 150 feet and accommodated 10,000 bathers. The adjoining pool house still stands. National Register No. 79000529. (LOC.)

Fleishhacker Pool and Bath House was a $1.5 million project financed by philanthropist and civic leader Herbert Fleishhacker. Jonathan Haeber, in his post on Terrastories.com, describes the landmark: "The Fleishhacker Pool opened in April of 1925 to a crowd of 5,000. Butressing the edge of [sic] the pool was the 450-foot-long Bath House—a Mediterranean, Italianate structure with three elaborate entrances, all surrounded by an Ionic order of pilasters. Inside were separate wings for men, women, and children. These wings were naturally illuminated by 22 skylights. Upstairs was a grand restaurant that looked out to the 1000-foot-long pool on one side and the Pacific Ocean on the other." National Register No. 79000529. (Both, LOC.)

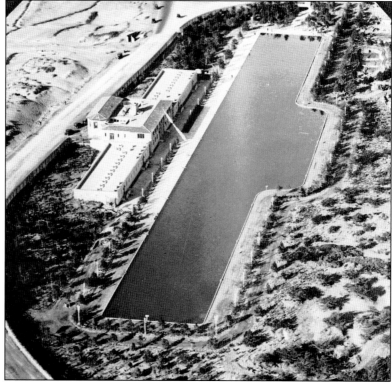

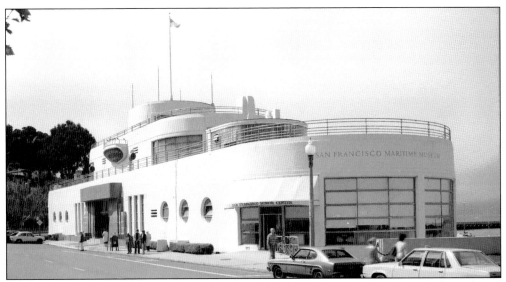

San Francisco's Aquatic Park Historic District is bounded by Van Ness Avenue and Beach and Hyde Streets. At one time, it was called Black Point Cove, where the Mermaid Baths and the Dolphin Club supplied bathing suits and towels to swimmers. Between 1936 and 1939, the WPA funded construction of a casino restaurant, a three-story, white concrete structure designed to resemble a streamlined battleship. The casino was not popular and was eventually replaced by the maritime museum seen in this image. (LOC.)

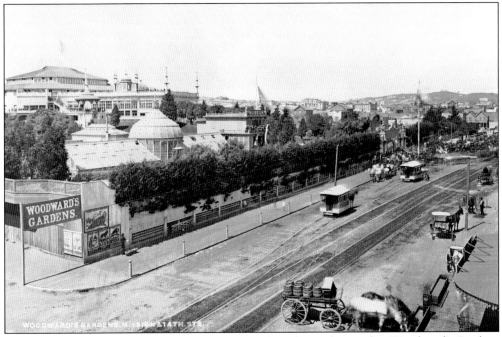

The site of Woodward's Gardens is recognized with a plaque that reads: "Woodward's Gardens occupied the block bounded by Mission, Duboce, Valencia, and 14th Streets with the main entrance on Mission Street. R. B. Woodward opened his gardens to the public in 1866, as an amusement park catering to all tastes. It was San Francisco's most popular resort until it closed in 1892." California Landmark No. 454. (LOC.)

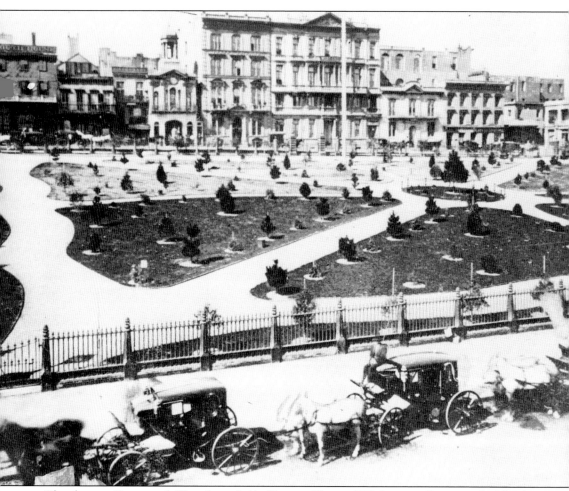

The plaque at Portsmouth Plaza, bounded by Kearny, Clay, and Washington Streets reads: "On this spot, the American flag was first raised in San Francisco by Commander John B. Montgomery, Captain of the ship Portsmouth, July 9, 1846." This plaza was the site of the first public school building in 1847. As the first public square in San Francisco, it has been a community gathering place and neighborhood park for over 160 years. An account from the *San Francisco Chronicle* dated October 29, 1916, explains, "Through the sixties and seventies the plaza looked as fair and blooming as a maiden at a May festival. Brightly shone the sun over its greenery, its flower-bordered walks, its central fountain and the gilded spear tops on the black iron fence." California Landmark No. 119. (LOC.)

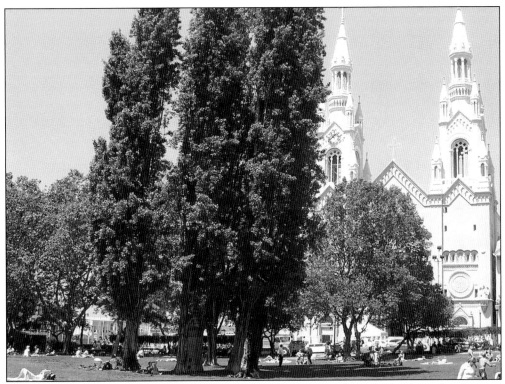

One of San Francisco's three original parks, Washington Square is bounded by Columbus Avenue, Stockton, Filbert, and Union Streets, and dates to 1850. Then, it was a cemetery and goat pasture. Years later, it was landscaped and redesigned by William Eddy. Residents still call the square "Il Gardino," Italian for "the garden." A beautiful park turned into the scene below when refugees made temporary camps after the 1906 earthquake and fire. More than 600 refugees lived in the square for over one year. An integral part of the square is SS Peter and Paul Church, pictured above. Cecil B. DeMille filmed workers during construction of the church and used the scene to show the building of the Temple of Jerusalem in the 1923 film *The Ten Commandments*. San Francisco Landmark No. 226. (Above, CAA; below, JBM.)

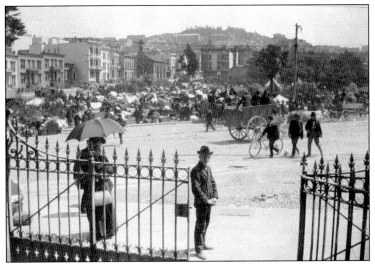

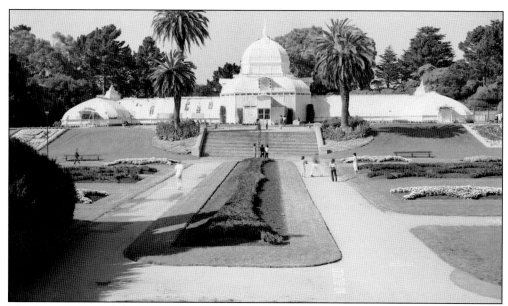

The Conservatory of Flowers in Golden Gate Park opened to the public in 1879. This masterpiece is 12,000 square feet and is the oldest surviving municipal wood-and-glass greenhouse in the United States. Patterned after the conservatory in Kew Gardens, England, it is still a distinguished example of late Victorian style, using early techniques of mass production and assembly of simple glass units. Built by greenhouse manufacturers Lord and Burnham, at the direction of San Francisco magnate James Lick, it is located on John F. Kennedy Drive. San Francisco Landmark No. 50, California Landmark No. 841, National Register No. 71000184. (Both, LOC.)

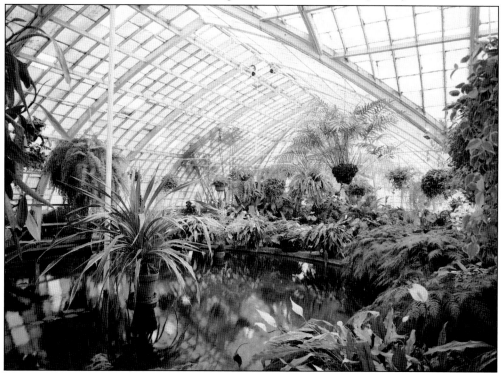

The two windmills in Golden Gate Park were the brainchild of John McLaren, Adolph Spreckels, and Reuben Lloyd. Located at the western end of the park, they were both constructed in the early 1900s to pump water into Golden Gate Park's irrigation system. Both were powered by west winds coming off of the Pacific Ocean, and together they pumped 1.5 million gallons of water each day. Pictured at the right is the northern Dutch Windmill, designed by Alpheus Bull Jr. Historic records indicate that in 1903, it pumped 20,000 gallons of water per hour at a cost of $25,000. Shown below is the southern Murphy Windmill was the largest of its kind in 1905 and was constructed with a $20,000 donation from Samuel Murphy, an executive of Hibernia Bank. Right, San Francisco Landmark No. 147; below, San Francisco Landmark No. 210. (Both, SFHC.)

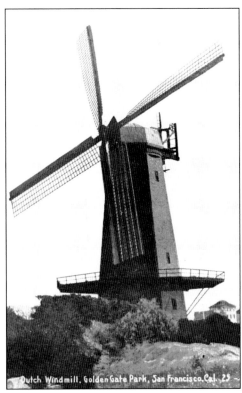

Dutch Windmill, Golden Gate Park, San Francisco, Cal. 25

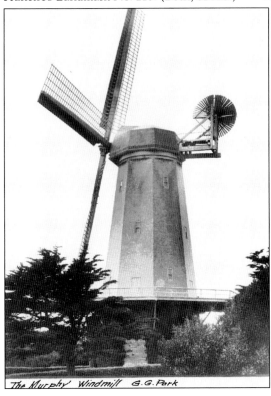

The Murphy Windmill G.G. Park

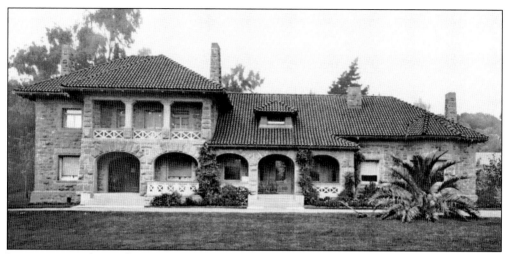

It was in 1896 that architect Edward R. Swain designed the Moorish-Gothic McLaren Lodge with 18-inch-thick exterior walls. Built to accommodate the office of the park commissioner, it became home to park superintendent John McLaren. It is located at the entrance to Golden Gate Park just off of Stanyan Street. San Francisco Landmark No. 175. (LOC.)

The Lawn Bowling Clubhouse and Greens were founded in 1901, and the clubhouse was built in 1915. They represent some of the earliest examples of planned recreational activities in Golden Gate Park. San Francisco Landmark No. 181. (SFHC.)

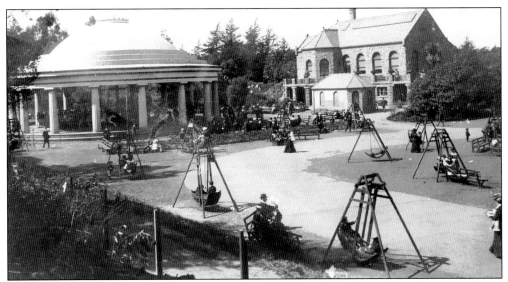

The sandstone Sharon Building in Golden Gate Park's Children's Quarters was designed by architects George W. Percy and Frederick F. Hamilton in 1888. This Richardson Romanesque–style structure was to serve as a canteen for visiting children and their mothers. At the time, it was the nation's first public playground. The Golden Gate Park carousel stands nearby. The current carousel was built in 1914 by the Herschell-Spillman Company. San Francisco Landmark No. 124. (SFHC.)

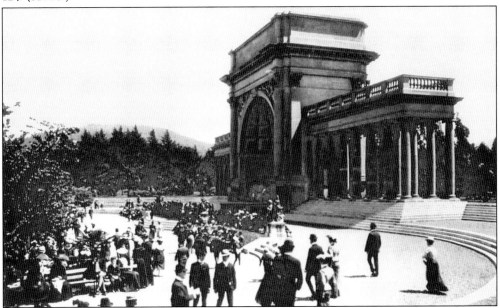

The Music Concourse is an open-air plaza within Golden Gate Park. Originally, the area was excavated for the California Midwinter International Exposition of 1894; after the fair, it was redesigned as pictured here. The Spreckels Temple of Music, also called the "Bandshell," was built in 1899 and dedicated to the people of San Francisco on September 9, 1900. Over 75,000 citizens sat on benches under the newly planted trees or on the surrounding lawn to listen to speeches and a concert honoring the dedication of the Bandshell. San Francisco Landmark No. 249. (SFHC.)

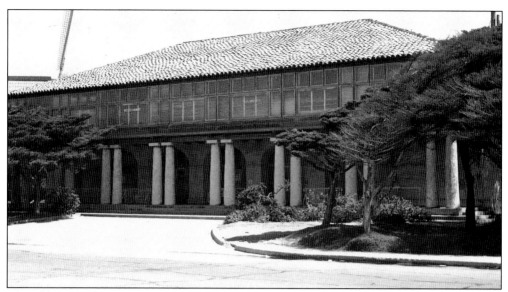

The address for this decorative Beach Chalet, built in 1925 and designed by Willis Polk, is 1000 Great Highway. Facing the Pacific Ocean on the outside, the inside is resplendent with frescoes by artist Lucien Labault depicting life in San Francisco. The chalet offered a lounge and changing rooms on the first level and a restaurant on the second. San Francisco Landmark No. 179, National Register No. 81000172. (SFHC.)

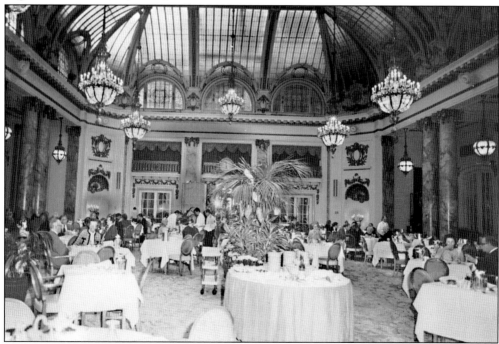

Although the grand Palace Hotel is not a designated landmark, the hotel's historic Garden Court is San Francisco Landmark No. 18. When the hotel was constructed in 1875 with 800 rooms, the area of the court served as an entry for horse-drawn carriages. Just a few years before the earthquake and fire, the Grand Court entry was redesigned into the Palm Court. For many years, diners have enjoyed elegant meals under a grand canopy of stained glass. (SFHC.)

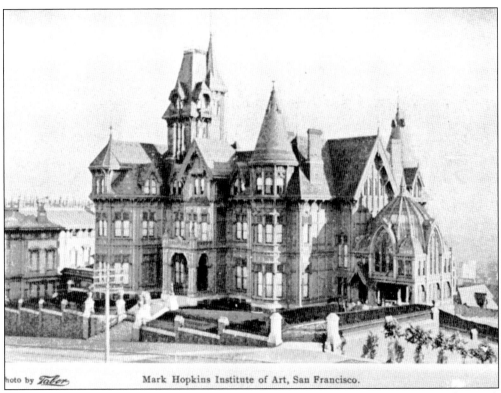

Photo by Taber Mark Hopkins Institute of Art, San Francisco.

In the late 1800s, the Mark Hopkins mansion (above) on Nob Hill was home to the Mark Hopkins Institute of Art. The fire following the 1906 San Francisco earthquake destroyed both the mansion and the school. A year later, the school was rebuilt on the site of the old mansion and renamed the San Francisco Institute of Art. The site is now California Landmark No. 754. In 1926, the school moved to its present location at 800 Chestnut Street on the slopes of Russian Hill (below). In 1961, the school took its modern name, the San Francisco Art Institute. San Francisco Landmark No. 85. (Above, LOC; below, SFHC.)

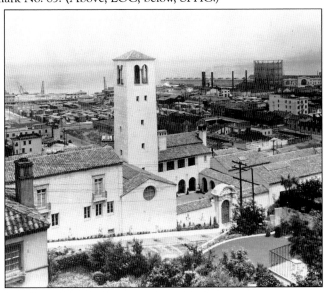

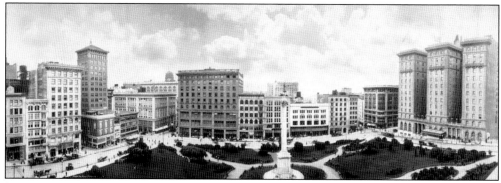

Union Square is now a 2.6-acre plaza bordered by Geary, Powell, Post, and Stockton Streets. It acquired its name because the area was used for rallies for the Union army during the Civil War. The square was built and dedicated by San Francisco's first American mayor, John Geary, in 1850. In 1903, the 97-foot monument Victory was dedicated to Adm. George Dewey's victory at the Battle of Manila Bay. California Landmark No. 623. (LOC.)

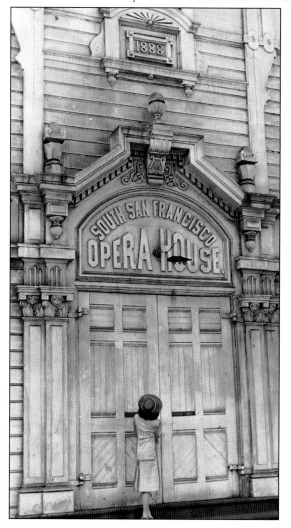

According to the National Register, the Bayview Opera House, also known as the South San Francisco Opera House, was built in 1888 at the request of Masonic Lodge No. 212. At the time, this area was a district of cottages, farms, and slaughterhouses. Considered a classic example of a western boomtown opera house, it was designed by German architect Henry Geilfuss and stands at 1601 Newcomb Avenue and Third Street. San Francisco Landmark No. 8. (SFHC.)

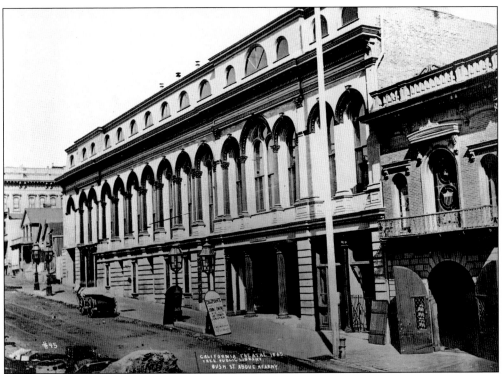

The site of the California Theater, at 444 Bush Street, is now marked with a plaque. The original theater was demolished and rebuilt in 1889, only to be destroyed in the 1906 earthquake and fire, never to be rebuilt. S.C. Bugbee and Son were the architects, and the theater cost $250,000 to build. California Landmark No. 86. (SFHC.)

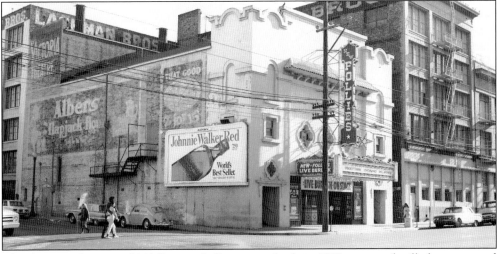

The 500-seat theater at 2961 Sixteenth Street, was built in 1908 as a vaudeville house named Brown's Opera House. After vaudeville became passé, it was transformed into a motion picture house. It was renamed El Teatro Victoria in the 1950s and New Follies in the 1960s, when it featured burlesque shows. Today, the Victoria is the oldest operating theater in San Francisco and has showcased such talents as Mae West, Bill Irwin, and Donald O'Connor. San Francisco Landmark No. 215. (SFHC.)

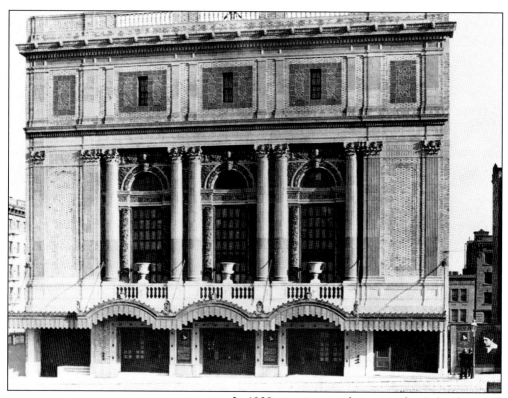

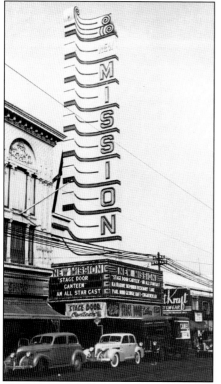

In 1908, construction began on the Columbia Theater, designed by Walter D. Bliss and William B. Faville. It opened on January 10, 1910, and among those who played there were Sarah Bernhardt and Isadora Duncan. It underwent several name changes: the Wilkes Theater, the Lurie Theater, and finally, the Geary Theater in 1928. For 40 years, at 415 Geary Street, the venue presented talents such as Edward G. Robinson, Basil Rathbone, and Boris Karloff. In 1967, it became the home of the American Conservatory Theater Company. San Francisco Landmark No. 82, National Register No. 75000472. (SFHC.)

The New Mission is a 2,800-seat motion picture house located at 2550 Mission Street in the heart of San Francisco's Mission District. It is composed of an Art Deco facade and promenade lobby, both designed in 1932 by architect Timothy Pflueger, and a large Renaissance/Neoclassical Revival auditorium, designed in 1916 by the Reid Brothers. The Mission Street elevation by Pflueger replaced the Reid Brothers' 1916 facade. San Francisco Landmark No. 245, National Register No. 01001206. (SFHC.)

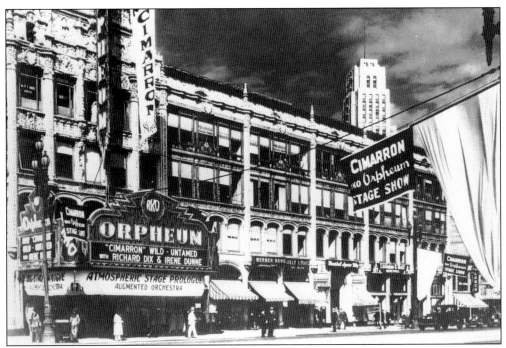

The original Pantages Theater operated from December 1911 until February 1926 at 939 Market Street. A while later, a new Pantages Theater opened at a different location at 1192 Market Street and was operated by Alexander Pantages as a vaudeville theater. He commissioned Scottish architect B. Marcus Priteca to design the building. Years later, it was purchased by RKO and reopened as a movie house renamed the Orpheum. San Francisco Landmark No. 94. (SFHC.)

The Castro Theater at 429 Castro Street is considered an exceptionally fine example of 1920s movie theater design. It was one of the first and finest major theaters built by San Francisco's oldest move business family, the Nassers. It is now the venue for San Francisco's annual film noir festival. San Francisco Landmark No. 100. (SFHC.)

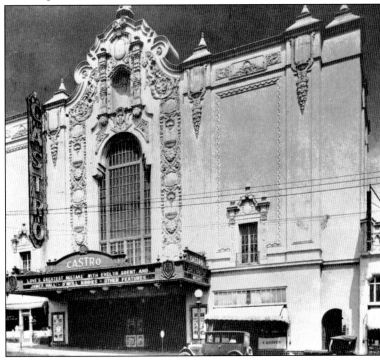

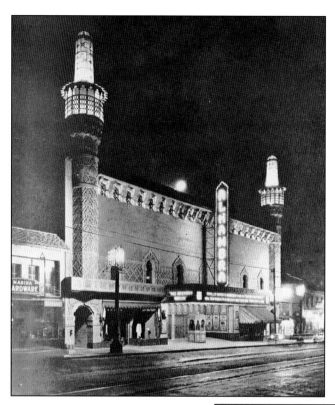

Another surviving neighborhood theater, dating to 1926, is the Alhambra at 2320–2336 Polk Street. Timothy Pflueger designed the Alhambra, as well as the Castro, Top of the Mark, and the Bal Tabarin, now named Bimbo's 365 Club. San Francisco Landmark No. 217. (SFHC.)

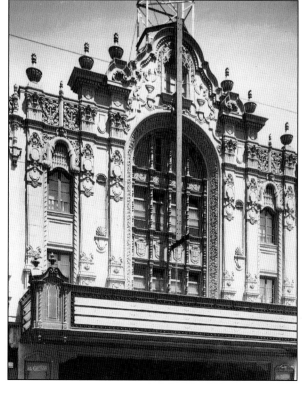

The El Capitan's interior was a wonderful example of Spanish Colonial Revival architecture from 1928. Unfortunately, the auditorium was gutted in 1964. The decorative facade is a reminder of the many lost historic architectural gems in San Francisco. San Francisco Landmark No. 214. (SFHC.)

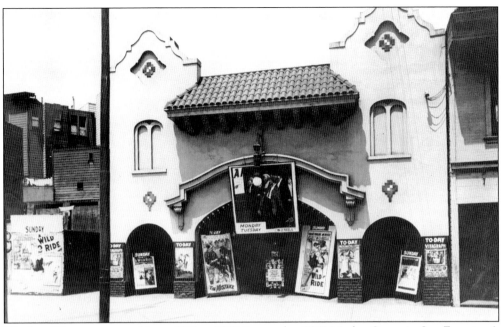

The Jose Theatre operated from 1913 to 1919. Located at 2362 Market Street in San Francisco's Eureka Valley, it served various uses throughout the years until it was converted to a restaurant. The Spanish style facade remains fairly intact. San Francisco Landmark No. 241. (SFHC.)

Built in 1910, this structure has had several names, including Turn Hall and the current San Francisco Women's Building. Turn Hall comes from the German *Turnverein*, which translates as "exercise club," and was part of the Turnverein movement. The building, at 3548 Eighteenth Street, was sold to the San Francisco Women's Center in 1978 and continues to provide a venue for social gatherings. San Francisco Landmark No. 178. (LOC.)

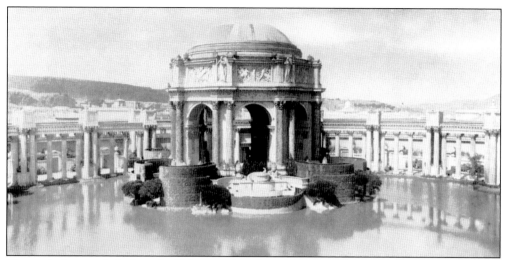

Clear minds prevailed when the Palace of Fine Arts, 3301 Lyon Street, was not destroyed after the Panama-Pacific International Exposition in 1915. San Francisco hosted the exposition in honor of the completion of the Panama Canal and also to celebrate the city's own resurrection after the 1906 disaster. Bernard Maybeck was tasked with the project, and he chose a design to resemble a Roman ruin. Although erected as a temporary building in 1914, the grand structure was so beloved by citizens that it was saved from the wrecking ball. Visitors can now gaze on a great rotunda of a Roman Classical character, with Corinthian columns and carefully detailed cornices, placed on two out-curving colonnades. San Francisco Landmark No. 88, National Register No. 86000089. (Both, LOC.)

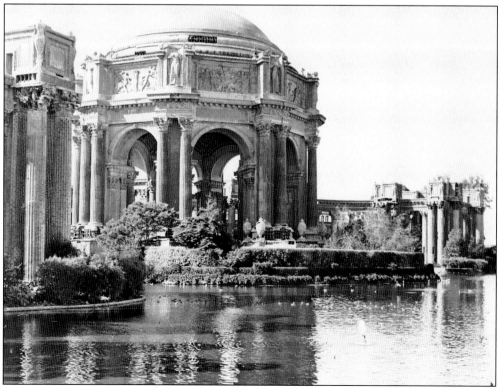

Another splendid architectural survivor is California Hall at 625 Polk Street. Built in 1912 and originally named Das Deutsches Haus, it represents the days when Polk Strasse was the main commercial street for San Francisco's many German immigrants. The design reflects that of Heidelberg Castle in Germany. San Francisco Landmark No. 174. (SFHC.)

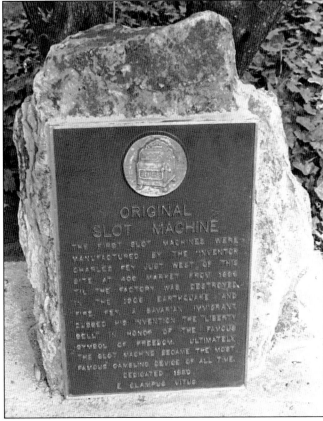

Fun began when Charles August Fey invented the Liberty Bell Slot machine in 1898 at 406 Market Street. It was a three-reel slot that gained international popularity, and it all began here, a site now designated with a plaque. California Landmark No. 937. (SFHC.)

This camera obscura is located at the Cliff House at 1096 Point Lobos Avenue. The point of this object is to illustrate physics and origins of the modern photographic camera. San Francisco's camera obscura was built by Floyd Jennings in 1946 as an attraction for nearby Playland-at-the-Beach. Years later, Jennings modified the building to look like a giant camera left behind by a tourist. It stands as the only surviving structure from the world-famous Playland. The image below is a 1965 aerial shot of the camera obscura situated in the center near the cliffs. Behind it are the Cliff House and Playland, to the right. National Register No. 01000522. (Both, LOC.)

Four

CIVIC
GOVERNMENT AND COMMUNITY PLACES

San Francisco Civic Center Historic District is bounded by Van Ness and Golden Gate Avenues and Market and Seventh Streets. The design of the civic center, comprised of 456 acres and 19 buildings, had its origins in the City Beautiful movement. (SFHC.)

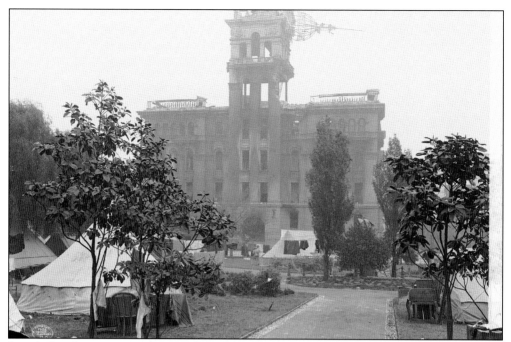

Long before the civic center became the center of the city's government offices, Portsmouth Square was the site of the Hall of Justice. The hanging dome and tents indicate this scene occurred just after the 1906 earthquake and fire. In July 1846, Captain Montgomery of the USS *Portsmouth* came ashore and raised the American flag in the plaza. At Kearny and Clay Streets, it was the center of activity in the town of Yerba Buena, a hamlet of about 50 houses. California Landmark No. 119. (LOC.)

The Sacramento Block was built in the 1850s as a warehouse. In 1856, the San Francisco Vigilance Committee made the site its headquarters and arsenal and fortified it with gunnysacks, thus the name change to Fort Gunnybags. It was a simple, two-story Classical Revival building made of brick and stucco. The structure was located at 243 Sacramento Street near Battery, but now only a plaque identifies the site. (LOC.)

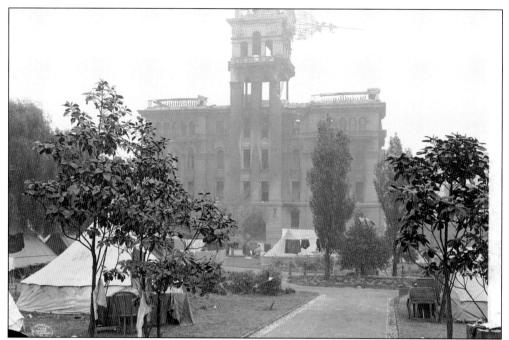

Long before the civic center became the center of the city's government offices, Portsmouth Square was the site of the Hall of Justice. The hanging dome and tents indicate this scene occurred just after the 1906 earthquake and fire. In July 1846, Captain Montgomery of the USS *Portsmouth* came ashore and raised the American flag in the plaza. At Kearny and Clay Streets, it was the center of activity in the town of Yerba Buena, a hamlet of about 50 houses. California Landmark No. 119. (LOC.)

The Sacramento Block was built in the 1850s as a warehouse. In 1856, the San Francisco Vigilance Committee made the site its headquarters and arsenal and fortified it with gunnysacks, thus the name change to Fort Gunnybags. It was a simple, two-story Classical Revival building made of brick and stucco. The structure was located at 243 Sacramento Street near Battery, but now only a plaque identifies the site. (LOC.)

Four

CIVIC
GOVERNMENT AND COMMUNITY PLACES

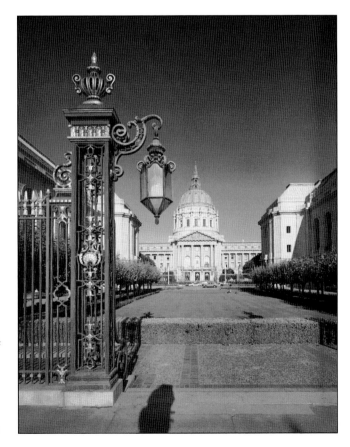

San Francisco Civic Center
Historic District is bounded
by Van Ness and Golden Gate
Avenues and Market and
Seventh Streets. The design
of the civic center, comprised
of 456 acres and 19 buildings,
had its origins in the City
Beautiful movement. (SFHC.)

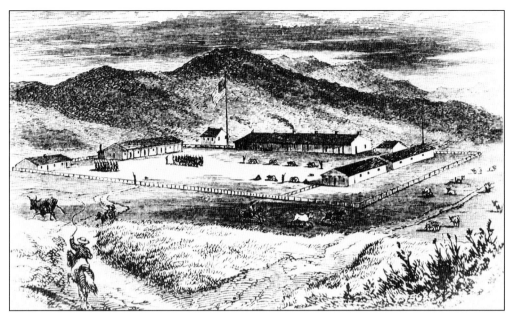

The Presidio of San Francisco was formally established on September 17, 1776. At the time, it was governed by Spain, later Mexico, and finally by the United States. In 1783, the garrison was comprised of only 33 men. Seized by the United States in 1846, the Presidio was a major command post during the Mexican War, Civil War, Spanish-American War, World Wars I and II, and the Korean War. The Presidio is now part of the Golden Gate National Recreation Area, providing a park, wooded areas, hills, and scenic views of the Golden Gate Bridge and San Francisco Bay. California Landmark No. 79, National Register No. 966000232. (Both, LOC.)

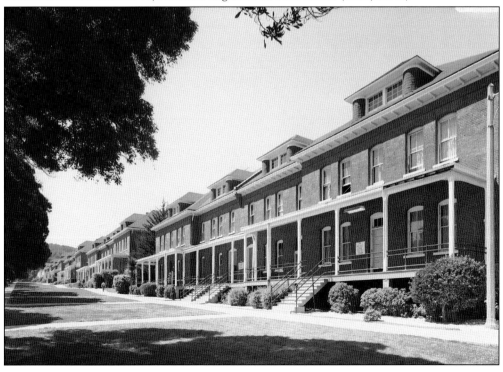

Fort Mason, originally named the Post at Point San Jose, was a fortified military base established in 1776 by the Spanish and claimed by the US Army upon California's admission into the Union in 1848. Following the Civil War, it became headquarters of the US Army 9th Infantry Regiment. The Fort Mason Historic District is bounded by Van Ness, Bay, and Laguna Streets. The three piers and four multistory concrete warehouses were constructed between 1908 and 1912. National Register No. 72000109. (LOC.)

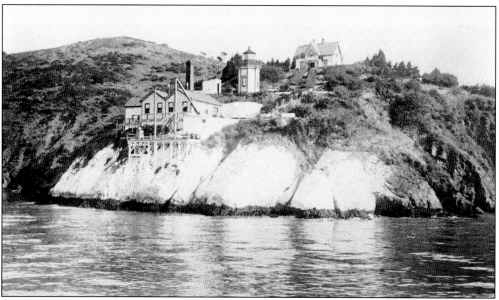

The Yerba Buena Island Lighthouse District covers 27 acres. Yerba Buena Island lay in the midst of growing ferry traffic. Thousands of commuters passed by the island every day in addition to all San Francisco–bound passengers from the transcontinental railroad terminus in Oakland. An 1876 government annual report indicates that a new, steam fog-signal building was completed on October 1, 1875. Lighthouse service records indicate the lighthouse tower itself was completed in 1873. National Register No. 91001096. (LOC.)

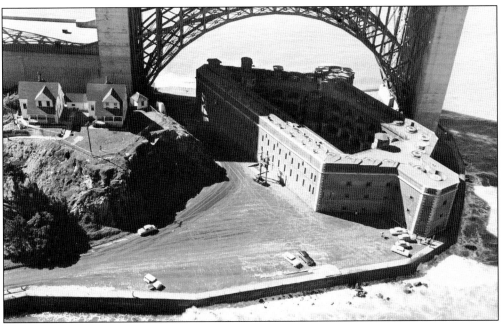

Fort Point has guarded the Golden Gate for over 150 years. Overlooking the Golden Gate, the fort is built of brick and trimmed and finished with granite. It has been called "one of the most perfect models of masonry in America." Built between 1853 and 1861 by US Army engineers, it was one of several forts planned for the protection of San Francisco Bay. In the years after the Civil War, it was used as Army barracks. During the 1930s, plans for construction of the Golden Gate Bridge included plans for the demolition of Fort Point. Fortunately, chief engineer Joseph Strauss recognized the fort's architectural value and built an arch that allowed the construction of the bridge over Fort Point. Retired military officers and civilian engineers founded the Fort Point Museum Association in 1959. They advocated a national historic landmark designation for this site, and on October 16, 1970, the designation was granted. National Register No. 70000146. (Both, LOC.)

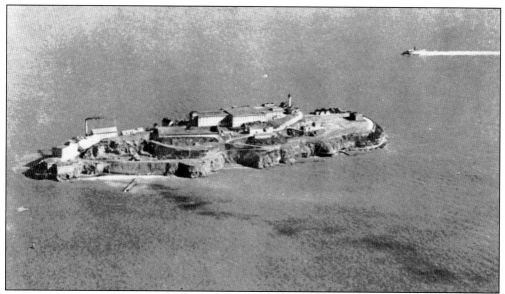

According to a National Register of Historic Places nomination form, the name Alcatraz is derived from the Spanish *Alcatraces*; over time, the name was Anglicized. While the exact meaning is still debated, *alcatraz* is usually defined as meaning "pelican" or "strange bird." The need to protect San Francisco Bay led the US Army to build a citadel, or fortress, at the top of the island in the early 1850s. The Army also made plans to install more than 100 cannons on the island, making Alcatraz the most heavily fortified military site on the West Coast. By the late 1850s, the first military prisoners were being housed on the island. In 1909, the Army tore down the citadel. From 1909 through 1911, the military prisoners on Alcatraz built the new prison, which became known as "The Rock." The island was utilized by the US Army for more than 80 years, between 1850 and 1933. At that time, the island was transferred to the US Department of Justice for use by the Federal Bureau of Prisons. National Register No. 76000209. (Both, LOC.)

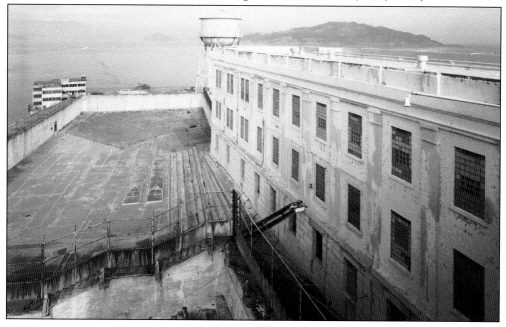

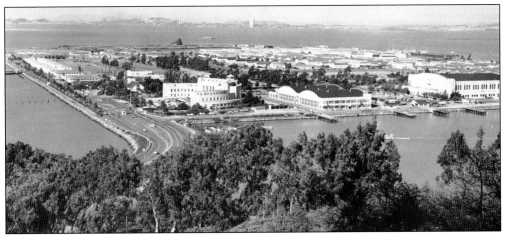

Treasure Island was constructed on shoals using sand, gravel, and topsoil from the bay and the Sacramento River delta. It connects to Yerba Buena Island, located between San Francisco and Oakland. This 403-acre man-made island was constructed between 1936 and 1937. Built under budget at $3,808,900, excluding buildings, it was the spectacular location of the Golden Gate International Exposition from February 18, 1939, to September 29, 1940. The island has also been a US naval station since 1941. California Landmark No. 987. (LOC.)

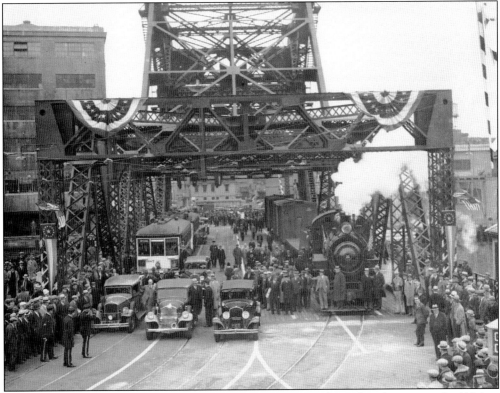

The Third Street Bridge spans the Mission Creek shipping channel and consists of a 143-foot riveted-steel, single-leaf bascule truss, complete with electrically driven hoist machinery. This is the only bridge of this type in the vicinity of San Francisco. It was designed by Joseph Baerman Strauss, who also designed the Golden Gate Bridge. San Francisco Landmark No. 194. (SFHC.)

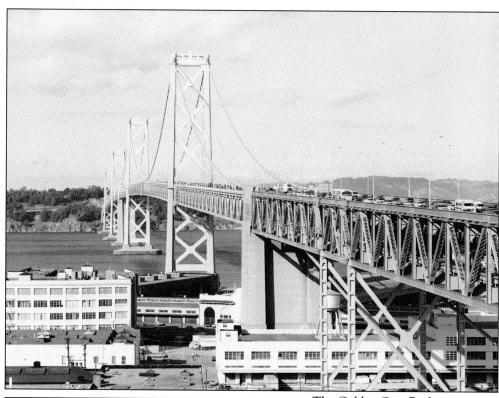

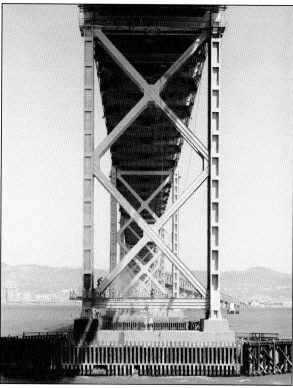

The Golden Gate Bridge was 75 years old in May 2012. Construction began in 1933 and ended in April 1937. It was dedicated on May 27, 1937. Engineer Joseph Strauss and architect Irving Morrow created a spectacular and beloved international landmark in a magnificent setting. The 4,200-foot span between two Art Deco towers was the longest bridge in the world until 1959. The Golden Gate Bridge has always been painted an orange vermilion known as "International Orange." Rejecting carbon black and steel gray, consulting architect Irving Morrow selected the distinctive orange color because it blends well with the span's natural setting. San Francisco Landmark No. 222, California Landmark No. 974. (Both, LOC.)

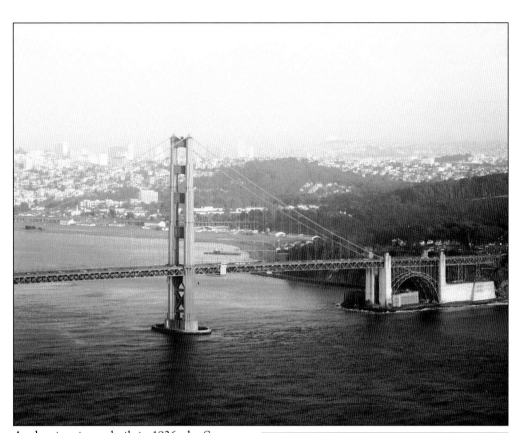

At the time it was built in 1936, the San Francisco–Oakland Bay Bridge was the longest bridge in the world. Its design is also noteworthy because it incorporates several different bridge types together to form a single structure with two levels of traffic. The Yerba Buena Island tunnel links the west spans and the east spans; its diameter of 58 feet makes it the tallest bore in the world. The upper deck originally carried six lanes of two-way auto traffic; the lower deck originally carried three lanes of two-way truck traffic and two sets of rails for interurban rail vehicles (streetcars). National Register No. 00000525. (Both, LOC.)

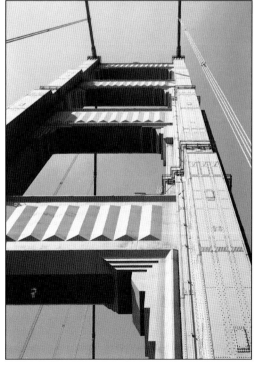

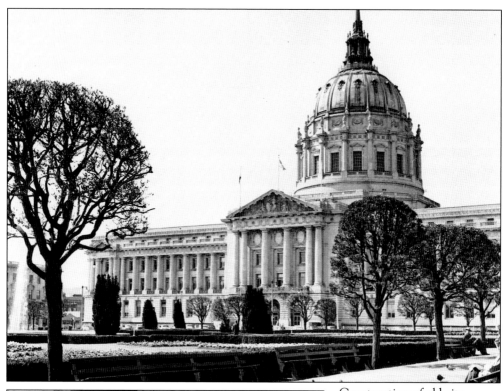

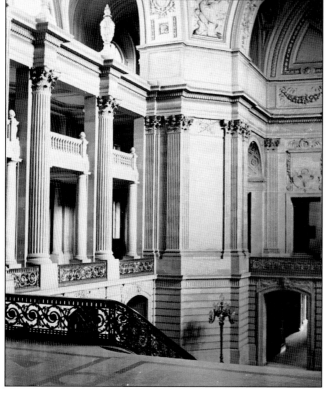

Construction of old city hall began in 1872 at Larkin Street near Grove Street. It was completed in 1899, amidst scandal after 27 years of construction and $6 million in costs, only to be destroyed in 1906. Mayor James "Sunny Jim" Rolph was elected in 1911, and in 1912, San Francisco voters approved an $8.8-million bond issue to build a new city hall. The winning design was that of Arthur Brown and included a dome similar to that of the Church of Les Invalides in Paris. It was completed at a cost of $3,499,262, the land costing $1,412,263. The first meeting in city hall chambers was held on October 9, 1916, at 400 Van Ness Avenue. San Francisco Landmark 21. (Both, LOC.)

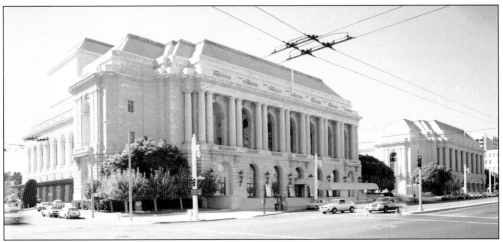

The War Memorial Complex, at 301 and 401 Van Ness Avenue in San Francisco's civic center area, is made up of two almost identical structures, the Opera House and the Veterans Building, separated by a formal court. Pres. Franklin D. Roosevelt designated the complex as the place where the United Nations Conference for International Organization would convene on April 25, 1945. San Francisco Landmark No. 84, California Landmark No. 964. (SFHC.)

This structure is a US Treasury mint built in 1854, four years after California became a state. Originally, the shoreline was just a few feet away from this site at 608 Commercial Street. Now, the building stands several blocks from the waterline. In 1875, the mint was moved to Fifth and Mission Streets. Years later, the structure was rebuilt as a four-story subtreasury, and after the 1906 fire, it was again rebuilt down to one story. San Francisco Landmark No. 34, California Landmark No. 87. (LOC.)

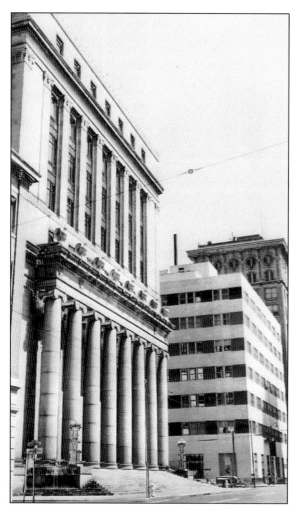

This image is of the old Federal Reserve Bank, designed by George W. Kelham in 1924 and located at 400 Sansome Street. The interior has an outstanding banking hall and lobby with murals by Jules Guerin, who also created the design for the 1915 Panama-Pacific International Exhibit. San Francisco Landmark No. 158, National Register No. 89000009. (SFHC.)

This is the US post office and courthouse at Seventh and Mission Streets. It was designed by James Knox Taylor, supervising architect of the United States Treasury Department, which had charge of all federal buildings of a civil nature. This is one of the best, clad in white Sierra granite and built between 1893 and 1905 by architect James Knox Taylor. Artisans were brought over from Italy to achieve the desired level of craftsmanship for the interior. Ground was broken in 1897, and the building, opened in 1905, was described as "a post office that's a palace." National Register No. 71000188. (LOC.)

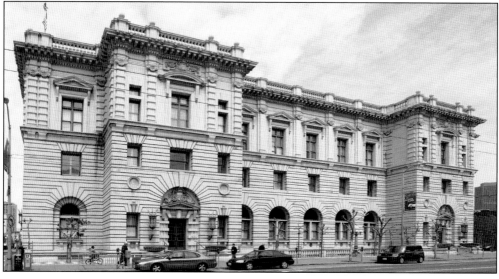

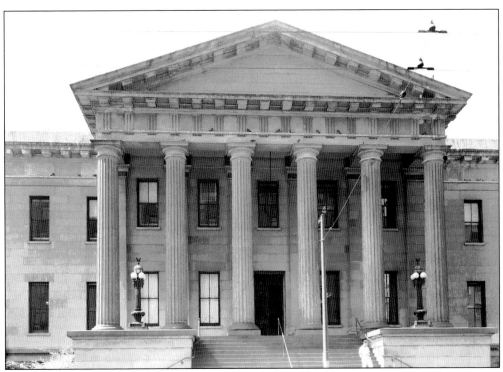

Designed by A.B. Mullett of Mills and Mullett, the second US mint was constructed in 1869 and completed in 1874. The cornerstone, laid on May 26, 1870, contains a copper casket of coins, newspapers, photographs, and other mementos. The address is 88 Fifth Street at Mission Street. It is a grand survivor of the 1906 disaster, saved by its iron shutters, 130-foot-high square brick chimneys, and brick masonry walls faced with Rocklin California granite base and blue-gray sandstone upper stories. In 1934, the San Francisco Mint housed one third of the nation's gold reserve. After construction of a new, updated mint in 1937 at 155 Herman Street, the Fifth Street structure was used as offices for various federal government departments. San Francisco Landmark No. 236, California Landmark No. 875, National Register No. 66000231. (Both, LOC.)

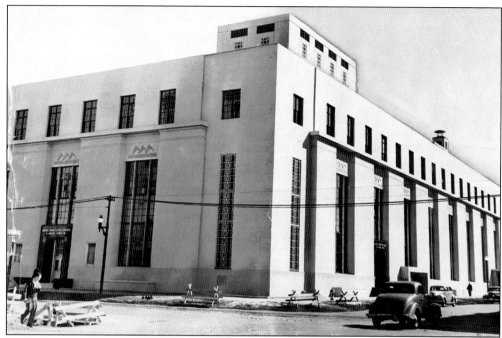

The Rincon Annex to the US post office was designed by Gilbert Underwood and built in 1939 by the George A. Fuller Construction Company. Built in the Streamline Moderne style, the undertaking was sponsored by the New Deal WPA. From 1941 to 1948, Russian immigrant painter Anton Refregier decorated the lobby with 27 watercolor murals depicting the history of California, influenced by the social realism of Diego Rivera. World War II broke out during the course of the project, and production was stopped on the mural, only to be completed after the war. Refregier ended the project with the completion of depctions of the Golden Gate Bridge, the war, and, finally, the creation of the United Nations in San Francisco. San Francisco Landmark No. 107, National Register No. 79000537. (Both, LOC.)

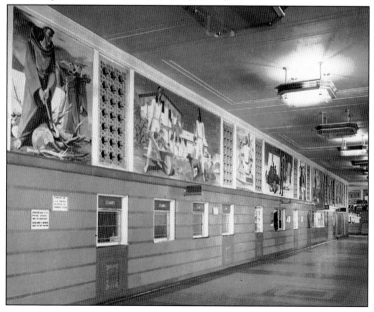

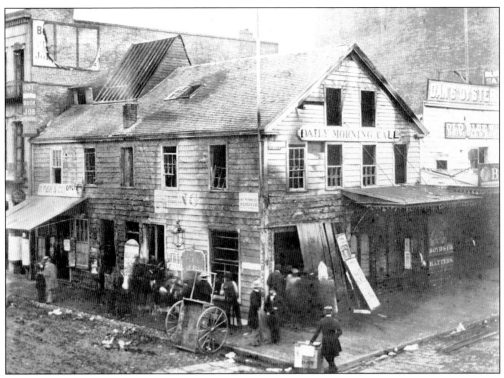

In 1860, this spot was near the shoreline of the San Francisco Bay. Today, it is where Chinatown meets the financial district at 601 Montgomery at Clay Streets. A plaque now marks the site of the Pony Express. The first Pony Express rider to reach San Francisco on the final relay, carrying mail from St. Joseph, Missouri, to California, arrived in San Francisco on April 14, 1860. A group of citizens escorted the rider, mounted on his decorated pony, to the office of the Alta California Telegraph Company, pictured above, then headquarters of the Pony Express. California Landmark No. 696. (Both, SFHC.)

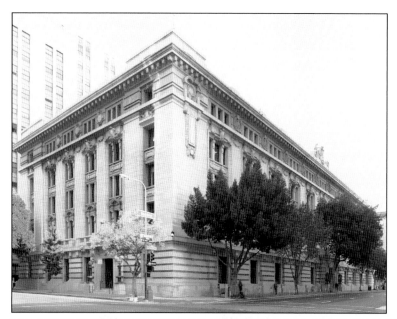

Designed by George W. Kelham, the main branch of the San Francisco Public Library was opened in 1917 as part of the San Francisco Civic Center complex. California tonalist Gottardo Piazzoni created 10 major murals that were installed in 1931 and 1932; four more were completed in 1945 but were not installed until the 1970s. (LOC.)

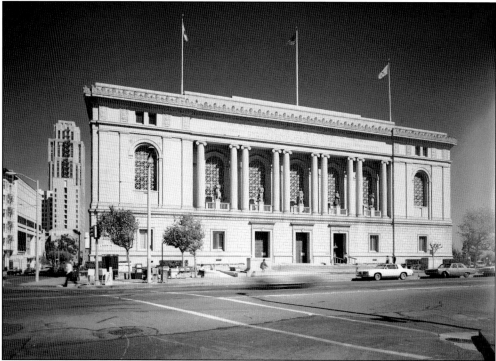

Regarding this landmark, Noehill.com states: "The United States Congress established the US Customs Service in 1789 to collect duties and taxes on imported goods. Until the federal income tax was created in 1913, customs funded virtually the entire government. In 1905, Eames and Young, a St. Louis architectural firm, won a national design competition for a new custom house at 555 Battery Street. Construction was not completed until 1911, delayed due to the 1906 disaster. It is a splendid example of the Beaux Arts Classicism style of architecture." National Register No. 75000475. (LOC.)

San Francisco's Ferry Building, at Market Street and the Embarcadero, opened on July 13, 1898. Designed by A. Page Brown, the building's most prominent feature was the tower rising 235 feet and visible for much of the length of Market Street. The clock faces on the tower were the largest in the United States at the time. San Francisco Landmark No. 90, National Register No. 78000760. (LOC.)

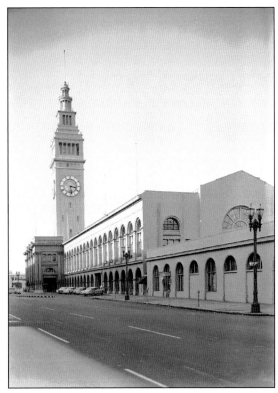

Piers 1, 1 1/2, 3, and 5 opened in 1918 and are now part of the Central Embarcadero Piers Historic District. The National Park Service website states, "The ferryboats *Delta King* and *Delta Queen* provided overnight connections between San Francisco and Sacramento from Pier 1 1/2, making it an important gateway for public travel to the interior of the state. Pier 3 and Pier 5 served primarily freight shipping." National Register No. 02001390. (LOC.)

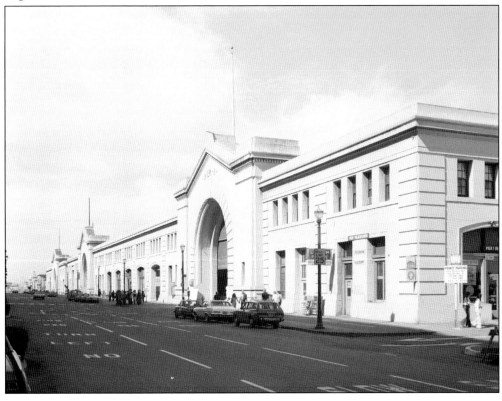

The California Armory and Arsenal was designed by state architect John F. Woollett in 1914 to house the coastal artillery, the naval militia, signal corps, engineering corps, and several other divisions of the California National Guard. It is located at 1800 Mission Street. For about 20 years from the 1920s to the 1940s, the Mission Armory was San Francisco's primary sports venue and was nicknamed "Madison Square Garden of the West." San Francisco Landmark No. 108, National Register No. 78000758. (SFHC.)

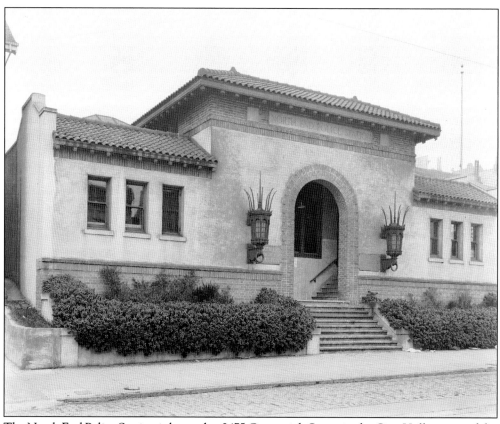

The North End Police Station is located at 2475 Greenwich Street in the Cow Hollow area of the Marina District. It was built for the 1915 Panama-Pacific International Exposition. A September 27, 1913, *San Francisco Call* article states, "The much talked of North End police station was formally created this morning when Chief White assigned Lieutenant Marcus Anderson to duty at the district, with the title of acting captain." San Francisco Landmark No. 218. (SFHC.)

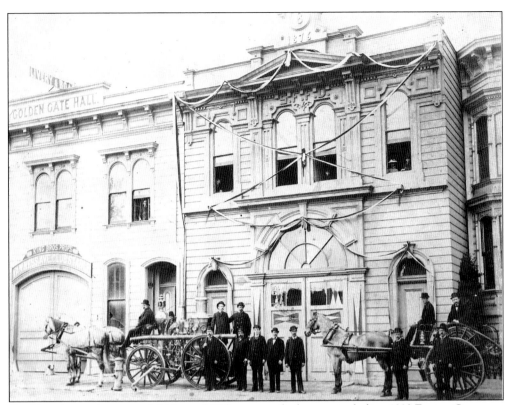

San Francisco enjoys several 19th- and 20th-century firehouses, including 1893 Engine Company No. 8, shown above, built by Henriksen and Mahoney in the typical, utilitarian style of the day. Located at 1648 Pacific Avenue, it was used for its intended purpose until 1963. Below is Engine Company No. 23, at 3022 Washington Street, designed by city architect John Reid Jr. in 1917. It was in service until 1980. It is crowned with Spanish tile of the Mission Revival style and has two main apparatus doors flanked by terra-cotta composite pilasters and Greek Revival molding. No. 23 was used as the storage facility for the department's toy program and as a medical supply station. Other existing historic firehouses are at 466 Bush Street, 1152 Oak Street, 1348 Tenth Avenue, and 2501 Twenty-fifth Street. Above, San Francisco Landmark No. 188; below, San Francisco Landmark No. 93. (Both, SFHC.)

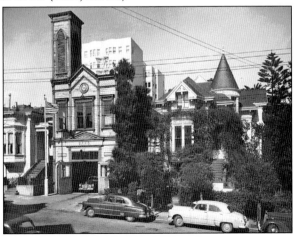

Francis Scott Key wrote "The Star-Spangled Banner." This Golden Gate Park monument, erected in 1888, is dedicated to Key. It was commissioned by San Francisco philanthropist James Lick and designed by sculptor William W. Story. San Francisco Landmark No. 96. (SFHC.)

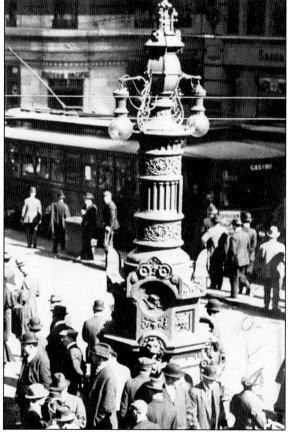

Lotta's Fountain was gifted to the City of San Francisco by Lotta Crabtree on September 9, 1875. She began her career at age eight and became one of the city's most popular entertainers of the time. Standing by the fountain at Market, Geary, and Kearny Streets, Luisa Tetrazzini sang on December 24, 1906, in the aftermath of the big quake and fire. Every year since then, on April 18 at 5:13 a.m. survivors of the earthquake gather in remembrance. San Francisco Landmark No. 73, National Register No. 75000475. (SFHC.)

Erected in 1847 and opened on April 3, 1848, the first public school in California was here, where there is now a plaque in Portsmouth Square. An 1853 account by Charles P. Kimball explains: "In April 1847, the number of inhabitants, exclusive of Indians, was 375. Eight months afterwards, when a census was taken by the Board of School Trustees, the number exceeded 800. Of these there were adult males, 473; adult females, 177; children of age proper to attend school, 60." California Landmark No. 587. (LOC.)

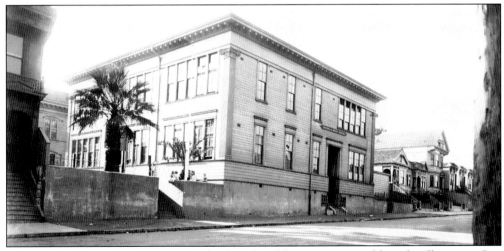

The Irving Murray Scott Primary School is the oldest surviving public schoolhouse in San Francisco. It began in 1865 as the Potrero School at Twentieth and Kentucky Streets, then moved to Minnesota near Twenty-first Street. The existing building was added in 1895 at 1060 Tennessee Street, financed by the superintendent of Union Iron Works, Irving Murray Scott, after whom the school was renamed. It emphasized manual trades for the boys and homemaking skills for the girls, making it the first school to offer cooking classes. San Francisco Landmark No. 138, National Register No. 85000714. (SFHC.)

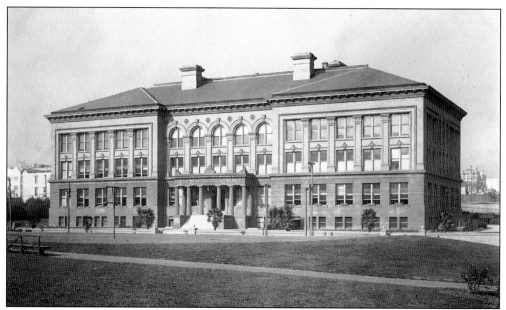

Pictured on its original site in San Francisco, where it has stood at 3750 Eighteenth Street since 1896, Mission High School is the oldest high school in the city. The original campus did burn down in 1922 and was replaced and dedicated on June 12, 1927. Originally, girls and boys had separate courtyards. The boys' area has a 100-foot tower and the girls' area a 172-foot baroque dome. San Francisco Landmark No. 255. (SFHC.)

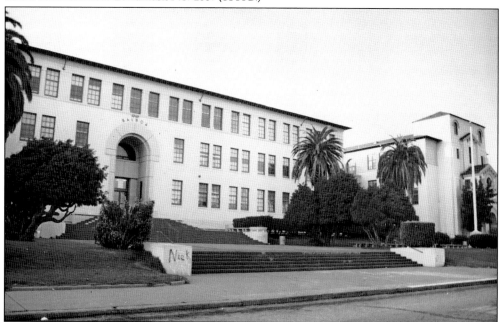

Balboa High School was named after 16th-century Spanish explorer Vasco Nunez de Balboa. Construction was completed in 1931 at 1000 Cayuga Avenue. Historic accounts indicate that in the spring of 1952, students at Balboa invented a variation on a conga line dance, which inspired bandleader and songwriter Ray Anthony to compose an accompanying hit song with the name, "The Bunny Hop." San Francisco Landmark No. 255. (SFHC.)

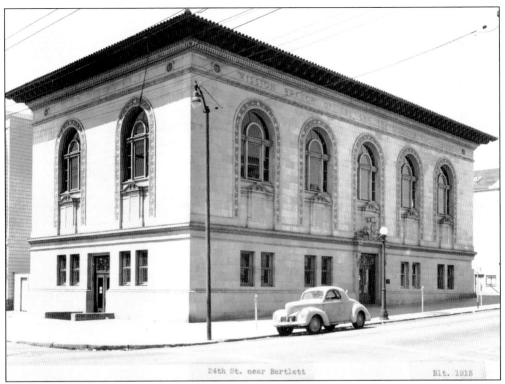

24th St. near Bartlett Blt. 1915

Above, 300 Bartlett Street is the site of one of four Carnegie-commissioned libraries in San Francisco. This, the Mission Branch, was built in 1916 and designed in Italian Renaissance style by G. Albert Lansburg. Beginning with 26 libraries funded in 1889, wealthy Scottish American industrialist Andrew Carnegie financed the construction of hundreds of such buildings throughout the United States. He went on to build as many as 60 per year and was responsible for approximately 1,679 in the United States alone. The Presidio Branch, below, at 3150 Sacramento Street is another, built in 1921. Above, San Francisco Landmark No. 234; below, San Francisco Landmark No. 240. (Both, SFHC.)

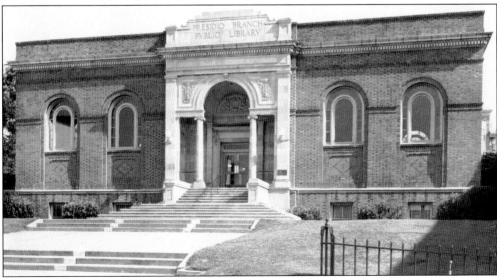

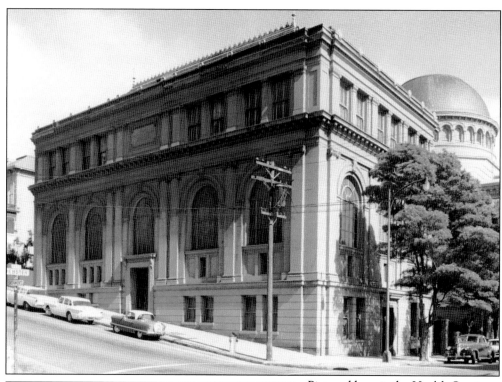

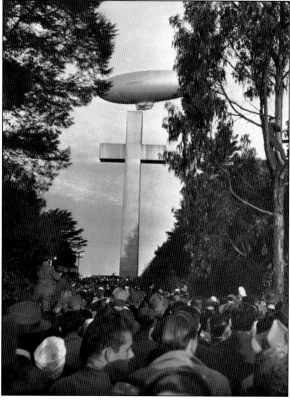

Pictured here is the Health Services Library, designed by architect Albert Pissis. Located at 2395 Sacramento Street, it is sometimes referred to as the "Lane Library." The dedication program states: "On November 1, 1912 . . . We meet to dedicate this handsome library building to the cause of education and to humanity, and in behalf of the Board of Trustees of Stanford University." San Francisco Landmark No. 115. (SFHC.)

Mount Davidson, with an elevation of 928 feet, is the highest natural point in San Francisco. Adolph Sutro purchased the land in 1881 at the time when the area was called Blue Mountain and later, renamed Mount Davidson for George Davidson, a charter member of the Sierra Club. Mount Davidson Monument and Park were inaugurated by Pres. Franklin D. Roosevelt in 1934. San Francisco Landmark No. 219. (LOC.)

The Lone Mountain Cemetery site, sometimes referred to as Laurel Hill, was in the area of what is now 3333 California Street from 1854 to 1946. Lone Mountain Cemetery, named after the towering sand hill just south of Geary Boulevard, opened for business on May 30, 1854. Buried there were civic and military leaders, inventors, artists, and 11 US senators. None of the above remain at the site. California Landmark No. 760. (LOC.)

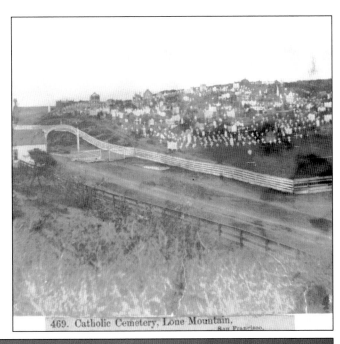

469. Catholic Cemetery, Lone Mountain, San Francisco.

The San Francisco Columbarium was designed by British architect Bernard J. Cahill in 1898. At that time, the area was the 167-acre Odd Fellows Cemetery. The address is now One Loraine Court in the Lone Mountain district. The first columbaria were built by Romans as structures to hold cremated remains. The Neptune Society acquired the building in 1979 and has since restored it as pictured here. San Francisco Landmark No. 209. (Carol M. Highsmith Archive, Library of Congress, Prints and Photographs Division.)

The first Shriners hospital opened in Shreveport, Louisiana, in 1922, and 13 other hospitals followed during the 1920s. The San Francisco hospital was opened in 1923 and is located at 1651 Nineteenth Avenue between Lawton and Moraga Avenues in the Central Sunset District. San Francisco Landmark No. 221. (SFHC.)

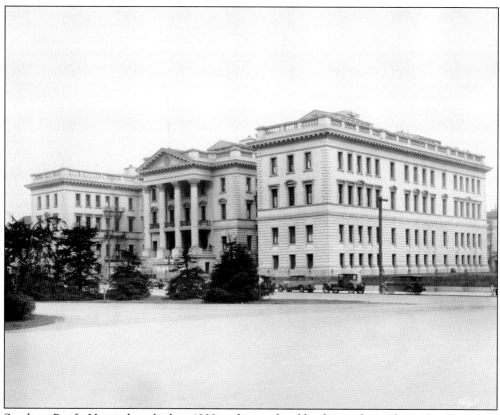

Southern Pacific Hospital was built in 1908, making it the oldest hospital complex in San Francisco. The Neoclassical building, designed by architect Daniel Paterson, included five structures in one city block: the hospital building, nurses' annex, Huntington Social Hall, powerhouse, and a paint shop. The structures were built at 1400 Fell Street and had 450 beds to serve the many employees of the Southern Pacific Railroad. San Francisco Landmark No. 191, National Register No. 89000319. (SFHC.)

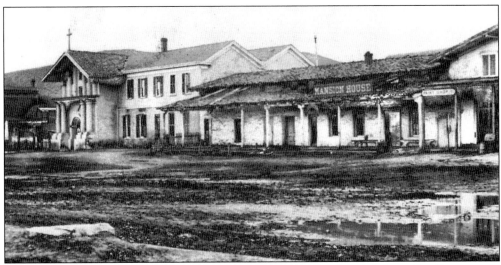

The first structure to be designated an official San Francisco landmark, Misión San Francisco de Asís, also known as Mission Dolores, was founded in 1776 by Fray Francisco Palou. It has stood on Dolores Street, between Sixteenth and Seventeenth Streets, for more than 200 years, making it the oldest building in San Francisco. Back in the 1850s, two plank roads were built connecting downtown to the mission, and the area then became a popular resort and entertainment spot. One part of the convent was converted to priests' quarters; another became the Mansion House, a popular tavern. The Mansion House was demolished in 1876 and was replaced with a brick church. An excerpt from the *San Francisco Chronicle* on July 16, 1916 reads: "To the north of the church along the line of Dolores street, and originally connected with the sacred edifice by a long row of adobes, stood the old Mansion House. In the days of the bears it was the regular resort of visitors to the Mission, whose numerous saddle horses hitched to the rail by the veranda looked like a cavalry halt while their thirsty riders refreshed themselves with milk punches." San Francisco Landmark No. 1, California Landmark No. 327, National Register No. 72000251. (Both, LOC.)

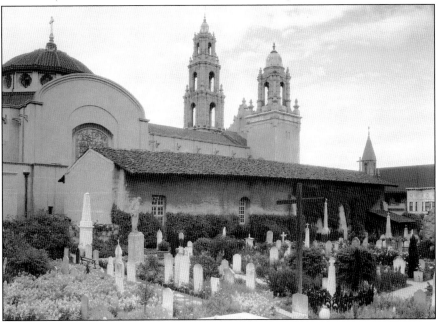

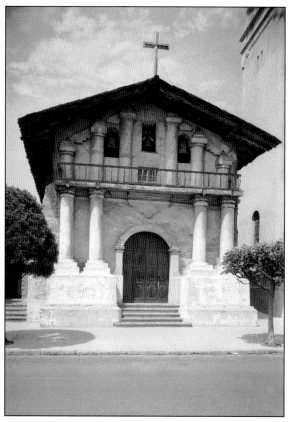

A plaque at Mission Dolores reads: "Founded in 1776 by Fray Francisco Palou, OFM and built by people of the Ohlone Nation of the village of Chutchui 1788–1791. To them we pay honor as the founders and first builders of this community and church." The mission has walls of sun-dried adobe brick four feet thick. The roof beams are of redwood, and the sloping roof is of tiles made by the Mission Indians. The floors are a mixture of clay, burned tile, brick, and wood. There are no nails in the building, which is secured by means of wooden pegs and rawhide. Buried under the altar of the mission church is Don Jose Joaquin Moraga, first comandante of the Presidio of San Francisco, and in the chapel are buried Capt. William Richardson, founder of the village of Yerba Buena, and many famous early San Franciscans, including the first governor of California under Mexican rule, Don Luis Antonio Arguello." (Both, LOC.)

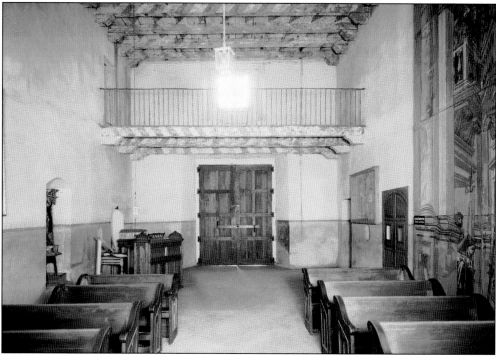

Old St. Mary's Church was the first building erected as a cathedral in California, serving the community from 1854 to 1891 at 660 California Street. Most of its stonework was quarried and cut in China, and its brick were brought around Cape Horn in sailing ships. The cathedral was rebuilt after the 1906 earthquake and fire. San Francisco Landmark No. 2, California Landmark No. 810. (SFHC.)

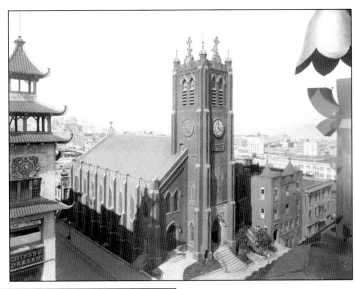

In 1854, a wooden building called St. Patrick's Church stood at the corner of Market and Annie Streets. By 1873, a new, larger church opened, and the old site was sold to William Ralston for construction of the first Palace Hotel. At one time, the church was in use by the Holy Cross Parish, and the image is of Holy Cross as it appeared after the 1906 earthquake. The current location of the original wooden church is at 1820 Eddy Street. San Francisco Landmark No. 6. (SFHC.)

First Unitarian Church moved into the building at 1187 Franklin Street in 1889. Designed by Percy and Hamilton in Richardson Romanesque style, it is one of the earliest examples constructed with rough-hewn granite. Situated on Cathedral Hill, it remains a physically impressive and socially active community church. San Francisco Landmark No. 40. (SFHC.)

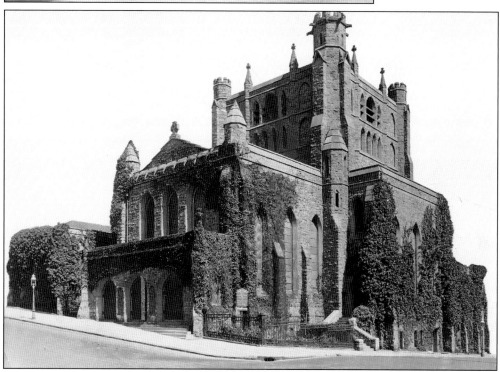

A survivor of the 1906 earthquake and fire, the Trinity Episcopal Church was designed by Arthur Page Brown and was built in 1893. Located at 1668 Bush Street, this impressively large structure was built in the Norman style with Colusa sandstone. Modeled after Durham Cathedral in England, it includes several decorative features, such as an angel and stained glass window, designed by Louis Tiffany. San Francisco Landmark No. 65. (SFHC.)

St. Mark's Lutheran Church is the oldest
Lutheran church in the West. The church
has stood at 1135 O'Farrell Street since
1895. It survived the 1906 fire because
nearby Van Ness Avenue was dynamited
to stop the blaze. According to historical
records, architect Henry Geilfuss designed
it after Christian Romanesque cathedrals
of the 11th and 12th centuries. San
Francisco Landmark No. 41. (SFHC.)

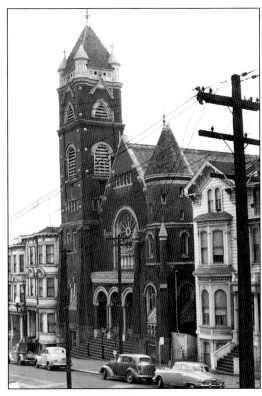

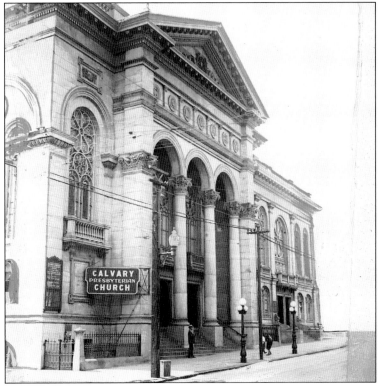

This is the third
location for the
congregation of
Calvary Presbyterian
Church, originally
built in 1855 on
Bush Street. After
several moves,
it stands at 2501
Fillmore Street with
the first service,
dating back to
Thanksgiving
Day in 1902. San
Francisco Landmark
No. 103, National
Register No.
78000755. (SFHC.)

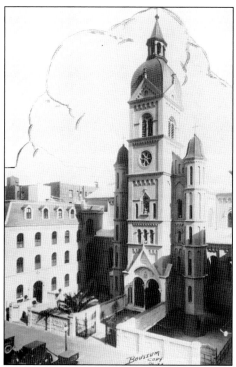

St. Boniface is the oldest German Catholic church in San Francisco. This structure, at 133 Golden Gate Avenue, was built literally upon the ashes of the previous church destroyed by the 1906 fire. A recent retrofit project uncovered ashes and crumbled mosaics. As the center of the German Catholic community in San Francisco, the original was dedicated in 1860, going well back into the city's history. San Francisco Landmark No. 172.(SFHC.)

Congregation Sherith Israel dates back to 1851. By the late 1890s, the sanctuary on Post Street was too small to accommodate the growing community. In 1903, architect Albert Pissis was commissioned to design this stunning structure, at 2266 California Street, with opalescent stained glass, frescoes, and a Murray Harris organ. National Register No. 10000114. (SFHC.)

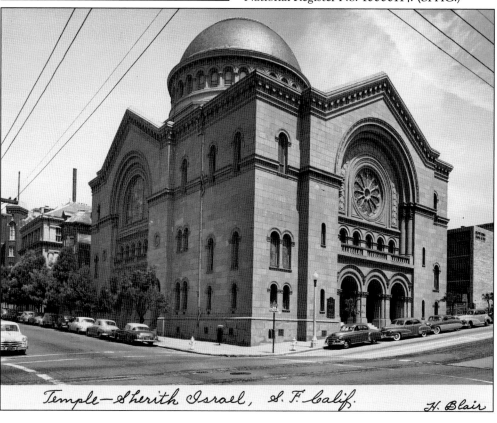

Temple—Sherith Israel, S. F. Calif.

H. Blair

Notre Dame des Victoires Catholic Church is also known as the "French Church." Its origins date back to 1848, when French priest Père Langlois arrived in San Francisco and began giving sermons in French, Italian, and Spanish. In 1856, Gustav Touchard founded a church at the current site, 564–566 Bush Street, that destroyed in 1906. Louis Brochoud built the new church and rectory in 1912, in Romanesque Revival style, modeled after the likeness of a church in Lyon, France. San Francisco Landmark No. 173. (SFHC.)

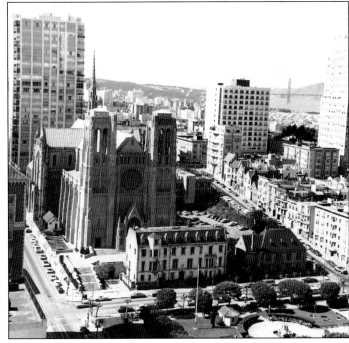

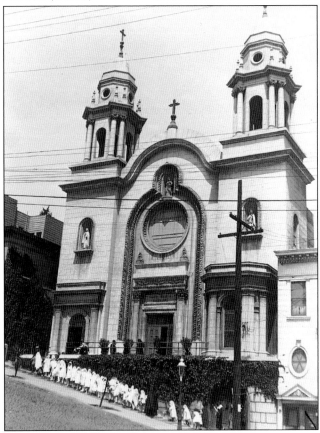

Our Lady of Guadalupe Church, also known as Nuestra Señora de Guadalupe, is at 906 Broadway, between Mason and Taylor Streets. The first church was constructed in 1906 and was subsequently rebuilt in 1912, following the design of architects Shea and Lofquist. Our Lady of Guadalupe Church served the local community until its closure in the 1990s. San Francisco Landmark No. 204. (SFHC.)

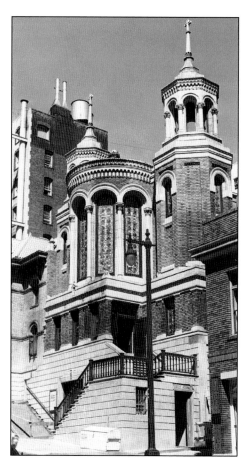

Grace Cathedral Close is adjacent to the cathedral at 1051 Taylor Street on Nob Hill. A close is term, mainly used in Britain, for a cathedral precinct. Grace Cathedral itself is an Episcopal church, originally Grace Church, founded in 1849 during the Gold Rush. It was destroyed in the great earthquake of 1906. Construction of the present structure, in the French Gothic style, was begun in 1928 and completed in 1964. San Francisco Landmark No. 170. (SFHC.)

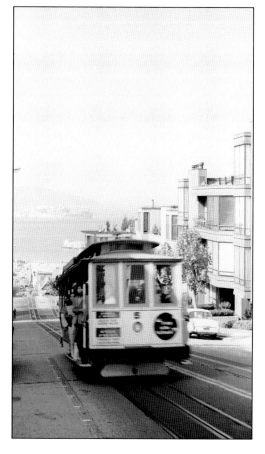

San Francisco's cable cars were designed in 1873 by Andrew Hallidie, a Scottish wire cable manufacturer. The beloved cable cars were actually in danger of being removed in 1947 when Mayor Roger Lapham declared "the city should get rid of all cable car lines as soon as possible." In response, the Citizens' Committee to Save the Cable Cars was formed, and fortunately, its members succeeded. National Register No. 66000233. (LOC.)

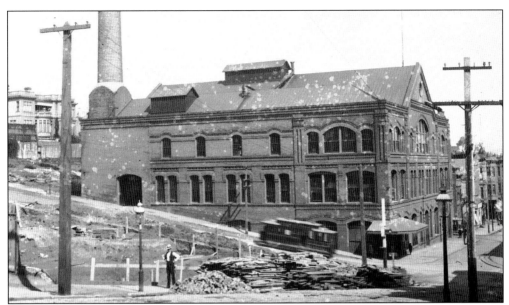

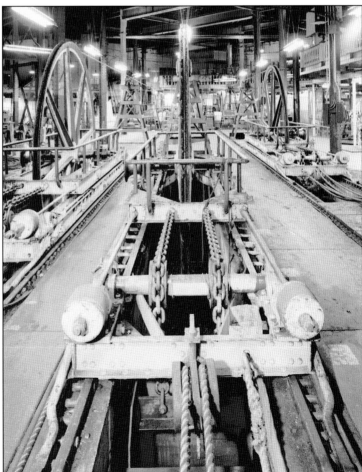

Pictured here around 1904 is the San Francisco Cable Car Barn and Powerhouse at 1200 Mason Street. The inventor of the city's cable cars, Andrew Hallidie, was also instrumental in the design of the powerhouse. Since 1887, this is the place where power is sent to the system with four cables and 25 miles of churning metal; 500-horsepower motors keep the system alive. It is the only surviving cable car barn and powerhouse in the city; there were 14 at one time. San Francisco Landmark No. 43. (Both, LOC.)

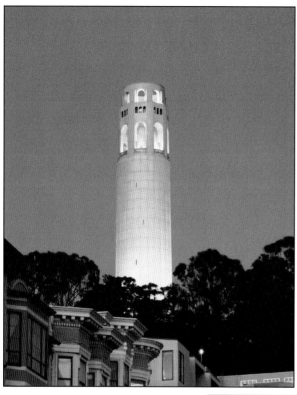

World-famous Coit Tower sits atop Telegraph Hill in San Francisco's North Beach district. Constructed in 1933, it was built at the bequest of Lillie Hitchcock Coit to commemorate the city's fire department. The historic plaque for the structure reads: "This 210 foot monument was built in 1933 with monies bequeathed by Lillie Hitchcock Coit to beautify The City she loved. Frescoes were painted in the interior of the newly built structure by local artists funded through the United States Government's Public Works of Art Project." The image below is of the *City Lights* mural by artist Victor Arnautoff. San Francisco Landmark No. 165, National Register No. 07001468. (Both, Carol M. Highsmith Archive, Library of Congress, Prints and Photographs Division.)

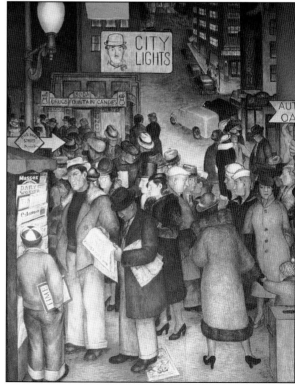

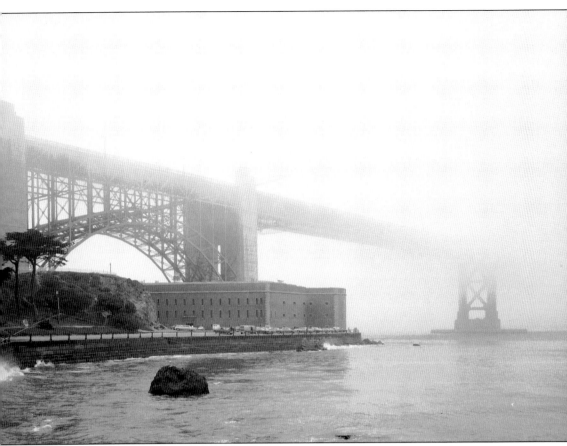

In closing this book, what would be better than an image—a complement to the cover image of the Golden Gate Bridge—of San Francisco's famous fog enveloping San Francisco Landmark No. 222? After all, 2012 is the 75th anniversary of the construction of this world-famous marvel. A weeklong opening celebration began back on May 27, 1937. The day before the bridge opened to vehicular traffic, 200,000 people were allowed to cross the bridge on foot and roller skates. In May 1987, the Golden Gate Bridge district closed the span to automobile traffic as part of the 50th anniversary celebration, and pedestrians were allowed to cross the bridge. That celebration attracted 750,000 to 1,000,000 people. The Golden Gate Bridge been declared one of the modern Wonders of the World by the American Society of Civil Engineers. It can also be declared a San Francisco landmark that is a perfect image of America. (LOC.)

DISCOVER THOUSANDS OF LOCAL HISTORY BOOKS FEATURING MILLIONS OF VINTAGE IMAGES

Arcadia Publishing, the leading local history publisher in the United States, is committed to making history accessible and meaningful through publishing books that celebrate and preserve the heritage of America's people and places.

Find more books like this at
www.arcadiapublishing.com

Search for your hometown history, your old stomping grounds, and even your favorite sports team.